ART, NOT CHANCE

Nine Artists' Diaries

True ease in writing comes from art, not chance
As those move easiest who have learned to dance.

Alexander Pope, *Essay on Criticism (1711), l.362*

art, not chance

nine artists' diaries

edited by *Paul Allen*

photographs by *Hugo Glendinning*

 CALOUSTE GULBENKIAN FOUNDATION, LONDON

Published by the
Calouste Gulbenkian Foundation
United Kingdom Branch
98 Portland Place
London W1B 1ET
Tel: 020 7636 5313

British Library Cataloguing-in-Publication Data
A catalogue record for this book is available from the British Library

Designed by Lucy Sisman
Printed by Expression Printers Ltd, IP23 8HH

Distributed by Turnaround Publisher Services Ltd, Unit 3, Olympia Trading Estate, Coburg Road, Wood Green,
London N22 6TZ
Tel: 020 8829 3000, Fax: 020 8881 5088, E-mail: orders@turnaround-uk.com

contents

Lovers and madmen have such seething brains,

Such shaping fantasies, that apprehend

More than cool reason ever comprehends.

The lunatic, the lover, and the poet,

Are of imagination all compact.

One sees more devils than vast hell can hold;

That is the madman. The lover, all as frantic,

Sees Helen's beauty in a brow of Egypt.

The poet's eye, in a fine frenzy rolling,

Doth glance from heaven to earth, from earth to heaven;

And as imagination bodies forth

The forms of things unknown, the poet's pen

Turns them to shapes, and gives to airy nothing

A local habitation and a name.

William Shakespeare, *A Midsummer Night's Dream, Act V, Scene I*

foreword

For the past few years the Gulbenkian Foundation has been running a regular grants pro-
gramme called 'Time to Experiment', to encourage professional artists from any branch of
the arts to set aside time simply to test new concepts, well in advance of any production
schedule. This opportunity has been highly valued for the way in which it has stimulated
the genesis of unexpected ideas. Periods of research and development are regarded as essential
in science and industry. In the arts they are often seen as self-indulgent or time-wasting.
Certainly they are the first things to go when budgets or production schedules have to be
trimmed. But this is short-sighted in economic terms alone. If the artist or artistic team has
time to work through ideas properly, the end product will be more successful. Audiences
and critics will be pleased and so too will box-office managers, publishers, funders and
politicians. The whole edifice we call 'the arts' in Britain is founded upon initially tentative
abstractions which emerge from the imaginations of relatively few artists.

So what have we learnt from offering 'Time to Experiment'? The making of art is a
peculiar process and while there are orthodoxies of good practice – thorough background
research, the draft or sketch, the read-through and 'blocking' process, the building up of
dance sequences or the arrangement of scores – there are no set rules. Indeed, a require-
ment of contemporary artists is that they should forget rules and forge personal routes.

This book, which has grown out of 'Time to Experiment', does not aspire to be an art-
making primer. Nine artists from different branches of the arts, 'successful' by many inter-
pretations of the term, were asked to keep a regular record of how they make their work.
The diary form is compelling to read. Unashamedly personal and anecdotal, it provides a
narrative which both shadows and illuminates the act of making art.

Certainly not one of the nine artists uses the word 'creativity'. Nor do they speak of
'aims and objectives' or of 'targets and outcomes'. They make no false promises about
'quality assurance', 'evaluation' or 'exit strategies'. We live in a culture where the produc-
tion of art is increasingly described in such eviscerating language while in reality it defies
analysis. Our artists write prosaically about the tasks in hand, a great deal about frustra-
tion, of displacement activity, the mental chore of sticking with an idea and of exaspera-
tion with other people. There are journeys and meetings, deadlines and budgets. It's not
all bad, however. There are breakthroughs, good days, amusements, encouraging friends,
inspiring collaborators and, sometimes, public acknowledgement.

The diaries show how new art derives from an economical synthesis of ideas from many sources, shaped by personal decisions and choices. Indeed, the act of selection is the discriminating factor: what to discard, what to disclose. It is 'art, not chance'. At some time or another the diarists record particular private experiences, occasionally even acutely painful or emotional ones. Of course, the tormented artist has become a Romantic cliché but our artists do not indulge in that other arts cliché, 'self-expression' – turning their art into a form of showy therapy. They honestly acknowledge the range of natural shocks, surprise, eroticism, anger, inertia, despair or pain that flesh is heir to, all of which can be a source to be drawn on. (Not that imagination alone isn't as good for most purposes: not every artist has to be a method actor all the time.) But the vulnerability is countered with a tough dose of self-possession, self-irony and, often, a robust humour.

All are conscious, even honoured, that they are part of continuing artistic traditions. But they are not aware of being deliberately 'contemporary' or 'postmodern' or 'groundbreaking' or any of the terms that others will come to use in describing their work. They have developed a habit of making themselves sensitive to the urgent expression of contemporary politics, of original modes of interpretation, the *zeitgeist* of new forms, fashions and vocabularies. Not one can be described simply as a *British* artist. Not only do they travel frequently, showing their work in other countries and meeting fellow practitioners from across the world, but an engagement with other cultures is the lifespring of their work: they appropriate, they collaborate, they synthesise. Through them none of us can any longer regard ourselves as the isolated inhabitants of one nation state.

Other boundaries are transgressed too. Though they have long-acquired specialist skills, all our artists have worked within other branches of the arts. (Strange to note, then, how the arts establishment still stubbornly segregates the 'art forms'.) No subject is too esoteric if they are compelled to pursue it. They delve into history and rearrange it. They can absorb whole areas of knowledge but simultaneously rejoice in subverting order – by highlighting the superficial, the incidental, the meticulous detail, the footnote. This, perhaps, is the prevailing theme of the art of our times: there is no single version of reality, no straightforward interpretation of events, no fixed image, no clear identity.

Art, we are often told, is 'in crisis', has lost its function, is not distinguishable from any other aspect of human culture. If that is the case, it is not clear why these nine artists are so driven to make it, when they could pursue profitable livings in other ways. The diaries provide evidence that the world would be impossible to imagine without artists, who with acute sensibility reflect and heighten human experience. They take risks, they pursue the limits of their curiosity, they know no boundaries in communicating the painful and the pleasurable, the protean and the mundane. And 'as imagination bodies forth' they 'give to airy nothing a local habitation and a name'.

We hope that this book will reach different audiences with different expectations. It will be of particular interest to those who are involved in educating and training would-be artists; it may influence those would-be artists who, if nothing else, may read of the enormous self-discipline and sheer hard work required and decide to stick to the day-job after all (on the other hand, it may strengthen their determination). It reveals the creative process to critics and academics and to audiences in the wider public who may find their enjoyment of art enriched. Significantly, it is also aimed at arts funders and decision-makers. If we can understand how art is made in real life we may be able to support it more effectively and make fewer demands.

Art, not Chance has been a delight to produce. The artists have enjoyed meeting each other and sharing private thoughts. Indeed, some claim to have benefited from the permission to be self-conscious. Paul Allen has been a calm and encouraging influence. Hugo Glendinning has produced photographs which are not simply illustrations but works of art in themselves, reflecting the lives of his subjects with originality and humour. Grateful thanks should also go to designer Lucy Sisman, to Felicity Luard, our Head of Publications and Sue Ullersperger her assistant, to our copy editor Jane Barry and to Cathy Goddard, our promotions consultant.

While the authors were writing their diaries, I told many people about the project. The response was enthusiastic and at times it seemed as if everyone I met in the arts wanted to make a diary of their own: artists of every discipline, producers, curators, editors and translators. This is not to make rash promises for a continuing series, but it certainly seems that there is value, as well as fascination, in holding a mirror up to a working process and some readers may wish to undertake the experiment themselves.

Siân Ede, *Arts Director*

introduction

Picasso is supposed to have remarked that when a group of critics meet up they talk about aesthetic theory, but that when artists get together they talk about turpentine. He was of course referring to an age when visual artists still regarded oil paint and how to remove it as a central preoccupation. But the point is that artists, of whatever medium, are essentially practical men and women. The commonly asked question: 'Where do you get your ideas from?' doesn't really interest them. Not because the supply of ideas is either unimportant or endlessly fertile but because the answer to the question is unknowable. If there were a source, comparable perhaps to a bank, a delicatessen, an encyclopaedia or an 'inspirational' landscape, everybody would go there and the results would not be distinctive or mind-opening enough to be identified as art.

Where the diarists in this book do describe the arrival of ideas – performance artist Bobby Baker driving round the streets of London or composer Errollyn Wallen simply hearing the rest of the world's music – it is clear that the basic data is available to everybody. It is alertness to the raw material and interaction with it that define artists. They have many more ideas than will ever become separate pieces of art because it takes more than one idea to make one piece. But having an idea, certainly the first idea, often seems the easy part. The realisation of that idea is harder and a sense that it can never be fully achieved may be the trigger that will urge the artist to start something new, and hopeful, after each piece is finished. If we are to believe another story, Michelangelo was so frustrated when he completed his *David* that he hit it with a chisel and shouted the Italian equivalent of 'Move, damn you!'

With a classical sculpture it's not hard to separate the idea (a shepherd given the beauty, grace and dangerousness of a young god) from the practical skill (the use of hammer and chisel on best Carrara marble). In considering the writing of fiction, however, we are much slower to identify as practical the craft necessary to realise a particular vision, as opposed to reporting facts, through the manipulation of language. Perhaps we take it for granted. But clearly not everybody finds it easy to make a good sentence, to express a thought, or a feeling, or an image, with clarity and power. And the decisions, when telling a story, about where to start it, what tone to adopt, how to order its events, how to claim its conviction – all are practical. Like the novelist, the poet too, undertakes a series of practical challenges (content, language, prosody) in order to render the luminous and poetic.

The word 'poet', it is worth noting, derives from the Greek for 'maker' or 'doer'. However, while technical skill in manipulating materials is immensely important in all artistic fields, it is not enough in itself. Just as the expression of 'vision' requires 'craft', so too does 'craft' require 'vision'. We treat practicality and imagination as if they were at opposite poles when all progress is made through an alliance between them.

Practicality is not the same as rationality in art, however. When a diarist says: 'I suddenly thought ...' there doesn't have to be a sense of careful ratiocination. Much of what an artist does is instinctive, capable of logical explanation afterwards, no doubt, but attractive at the time because it is what came next. The colloquialism to 'dream up' is a useful one, conveying not only the possibility that ideas are drawn from some unconscious well in the middle of the night, but the notion that 'dream' can also be an active verb, a conscious 'doing', undertaken in broad daylight. Could we ever train ourselves to do it better, as we do other functions of the mind or would the result be simply mechanical? Art has to surprise us and in order to make it artists have to surprise themselves. If you know in advance what you are setting out to achieve, it isn't worth the journey. The late Dennis Potter would never talk about what he was writing next, 'in case the magic leaks out'. Artists work to discover. More derivations: 'invent' comes from the Latin for 'find'; and 'story' and 'history' from the Greek for 'enquire'.

We know that different languages are good at expressing different things or the same things differently. Translation from one language into another can make us look at something in another light, from another direction. There is a special fascination in the fact that Jo Shapcott should choose to engage with another poet (Rilke) whose first language is German but who in this instance is working in French; that Lawrence Norfolk should choose a subject in which he has to find a voice for the mythic, heroic age of Ancient Greece and for a Romanian Jewish poet; that Tim Supple should test his own art and creative identity by directing Shakespeare, who helped shape what we recognise as the English language, in German, and should find the culture alien in every sense.

There are other languages beside the verbal. Shobana Jeyasingh's account of the early stages of working on a new piece demonstrates that when as a choreographer she steps outside recognisable patterns of communication in either contemporary or South Asian dance she invents a new language for each new work. Something comparable is happening when Joanna MacGregor 'prepares' a piano in the manner recommended by John Cage and then collaborates with a musician from yet another cultural tradition (South African, jazz-based) to discover a new musical language; or when Richard Wentworth 'interferes' with the visual narrative we may expect in a public gallery. We are invited to abandon or modify familiar languages as new sounds and sights comment on or argue with the old ones.

In *A Midsummer Night's Dream* Shakespeare links 'the lunatic, the lover and the poet'. This line often gets a laugh from those, artists or not, who share the view that everybody who works in the arts is at least a little mad. Shelagh Stephenson demonstrates in her diary how the artist shares not only the manic swings from exhilaration to despair, but also the monomania of both madman and lover. Everything suddenly connects, as a result not of a worldwide conspiracy that only you have spotted but as the product of an obsessive mind, your own. Everything connects with your current obsession and if you give in to it, it will take you down a road you will subsequently recognise as completely ludicrous. But it doesn't impair your practical ability. Nobody achieves as much as the obsessed.

In Britain we are ambivalent about the regard we show our artists, showering them alternately with award ceremonies and pejorative names. It is natural to feel more secure when the ground isn't being broken, and some ground-breaking does indeed turn out to be silly or, worse, destructive. What's more, many artists seem to live differently from the rest of us and by opting out of what used to be called the rat race they may unwittingly remind others of their presence in it. Choosing to accept poor material rewards, to work obsessively hard, to embrace risk, and brace themselves to withstand criticism – all this may seem like an implicit challenge to those who try to be good and useful citizens by avoiding all these things.

The irony is that the evidence of this book shows that the contemporary artist is rather good at living the life of the small-scale entrepreneur. She or he travels the cultural trade routes making a transaction here, selling a performance there, charging whatever can be got for a sight of the tricks and trappings and truths in the carpet-bag of his or her mind, filling in tax forms, trying to comply with local law and lore. This is not an essay on subsidy, so we will ignore the question of whether this reduces the art, except to say that at some point in their diaries everybody wanted more time for their primary work, and felt a sense of frustration when other pressures – publicity, administration, funding applications – intruded.

Our attitude to artists, I suggest, is comparable to our attitude to our children; they are a very substantial part of our future and they illuminate our world. However, they are inclined to reveal their emotions too openly in public spaces. Better stay a bit aloof. When artists discuss their own working processes and the introspection which accompanies the highs and lows of the creative life, they offer themselves as hostages to this kind of condescension. But these nine artists – all successful in the sense that they have produced work that has been highly praised and validated by the market place – are enquiring, adventurous, as interested in the telling detail as the grand design, self-mocking, problem-solving, inventive, diverse, thoughtful, ambitious, open-minded, sexy, fun. Because they are artists it goes without saying that there is a self-consciousness about their diaries which

makes very different reading from the artless confessional mode which is one extreme of the genre; equally I believe they offer insights you do not read in interviews or formal statements about life, work and everything. These are snapshots of what it is like to try to make art in Britain now by people engaged in the daily struggle to make things that haven't been made before.

Paul Allen

Paul Allen is best known as presenter, for almost twenty years, of the Radio 4 arts magazine Kaleidoscope, *and more recently of the Radio 3 cultural discussion programme* Night Waves. *He is also a playwright, who has written for radio and theatre, and recently adapted Mark Herman's screenplay* Brassed Off *for theatre, which was presented in Sheffield and at the National Theatre before touring the country. He is a former chairman of the Arts Council Drama Panel and chairman of its New Writing Committee. He is vice-chairman of the Sheffield Theatres Trust and also a member of the city's Galleries and Museums Trust. He teaches dramaturgy at the University of Sheffield and holds an honorary doctorate of Sheffield Hallam University. His biography of Alan Ayckbourn is published by Methuen in 2001.*

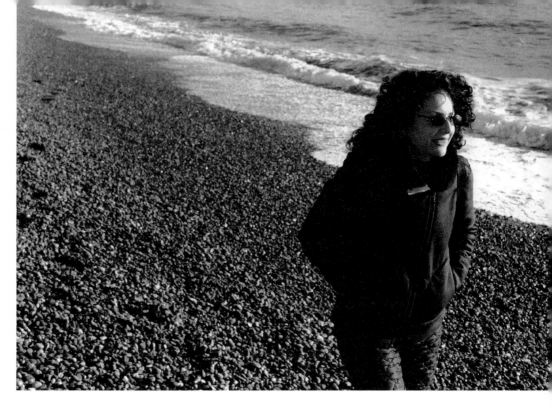

musician
Joanna MacGregor

Joanna MacGregor trained at the Royal Academy of Music. She is in world-wide demand as a classical concert pianist and has played with many of the greatest orchestras, and collaborated with eminent conductors. She is also committed to the work of living composers from the serious contemporary tradition, like Harrison Birtwistle or Hugh Wood, and champions the work of composers with a jazz background, such as Django Bates or Andy Sheppard. As Artistic Director of SoundCircus, her new music promotion company, she has programmed Chick Corea and the London Sinfonietta in the same Manchester concert series. In 1998 she launched SoundCircus as a record label, and its repertoire ranges from Byrd and Dowland to John Cage, Talvin Singh and Lou Harrison, whose piano concerto she recorded with the Sydney Symphony Orchestra. She is a member of the Arts Council of England and Professor of Music at Gresham College, London.

Joanna MacGregor's diary begins in October 1999. Though its main focus is the genesis of a collaboration with the South African musician Moses Molelekwa, she is also playing in international classical concerts and festivals and recording a Bach series for BBC TV.

27–30 October 1999

I first met Moses Molelekwa in a cigar bar in Melville, Johannesburg. It was my fifth or sixth visit to South Africa, and I was talking to a large crowd of mainly jazz and pop musicians about a small internet recording label I'd set up. It had been a long day of back-to-back seminars, but Andrew Missingham from the British Council really wanted to take me to meet Moses, a young jazz pianist and composer; Andrew had produced his album, *Genes and Spirits*, the year before. So we met over a beer at the Havana bar, where he was sitting with the three members of TeeKayZee, a very famous kwaito group. It was very casual; a bit of gossip, none of us talking about ourselves, or music, but just hanging out. Then they all got interested in a score I had with me of George Crumb's *A Little Suite for Christmas*, which is quite a graphic score, with instructions for playing inside the piano. Moses had never seen this before; his eyes lit up, and the band laughed at the thought of strumming the strings of a piano, or putting nuts and bolts between the strings, which John Cage is very fond of. After a couple of drinks I left; the next day I went to speak at another conference at Cape Town University, played a short recital (including the George Crumb piece), performed a few riotous numbers with the African percussion and dance group Amampondo at a jazz club, and came home.

17 November

Halfway through the Contemporary Music Network SoundCircus tour, and tonight the venue is the Queen Elizabeth Hall in London. It is full of friends, but when I'm taking my bows at the end, somebody is wolf-whistling like crazy, which I find very amusing (at this point in the tour I feel 103). It turns out to be Andrew; at the party afterwards he tells me he's had an idea about me and Moses and we must meet up.

Meet Andrew for a coffee in London. He gives me a copy of *Genes and Spirits* – would like me to think about some kind of collaboration with Moses. He's seen me work with Django Bates and Nikki Yeoh, both of whom are jazz pianists, but we both know that Moses's work is as much rooted in African music as in jazz. Andrew knows that I've been looking for ways of performing, or developing, African music in my repertoire – since recording John Cage's *Sonatas* and *Interludes* two years ago, I've been looking for ways to (convincingly) branch out of the exclusive Western tradition, which is virtually impossible on the piano. Leave to play three concerts with Boulez and the Chicago Symphony Orchestra.

11 January 2000

In the middle of a dodgy *Mail on Sunday* photo-shoot, David Jones rings, from Serious (concert promoters). Would Moses and I like to try something out at the Spitz? It's a great idea in terms of meeting a deadline; but the Spitz is a tiny, sweaty space and paradoxically that can be quite pressurised. Decide to go with it.

7 February

In Bristol, recording part of Bach's *48* for BBC TV series. Andrew rings – he can organise some dates in early July for us in South Africa, and David Jones can contribute to the cost of bringing over Moses so we can work out a set for the Spitz beforehand. The Grahamstown Festival are very keen; this means I'll have to cut short my annual visit to the West Cork Festival, but it's a great opportunity to get together and actually create something (at this point don't know what).

19 March

In the middle of a Mozart tour with English Sinfonia, decide to e-mail Moses. His album is very laid-back and dance-like, a lot of percussion and very African – occasionally dreamy, but with some great piano solos with his band. Obviously we'll do something different – two pianos, but nothing too cerebral. Moses is into computers so we decide, via e-mails, to programme some rhythm tracks. Moses wants to know about playing inside the piano, and about John Cage prepared piano. He's not confident about reading music – so I say, well, we'll improvise everything; and maybe you can teach me some of your music.

28 March

Decide to remind myself of the Spitz in London, and go to a packed Scanner/chamber orchestra collaboration there. The crowd love it. I think it's pretty terrible – the drum 'n' bass guys are great (and loud) but the material the strings are playing is repetitive and bland. This is the downside of collaboration, as I know only too well. Partners from different genres come together with every intention of producing fresh, original work, but end up with something cosmetic – two worlds grafted together with an unbridgeable scar running down the middle.

2 June

Bath Festival. Moses has arrived in England a few days before we start to rehearse. We've met once, e-mailed each other twice, and never seen each other play. Andrew brings Moses to a gamelan/John Cage 'prepared piano' concert I've directed as Artistic Director of spnm (Society for the Promotion of New Music). Moses is a man of few words but loves the tigerish gamelan instruments (me too; I was staggered to see them gleaming red and gold, when I arrived in the afternoon). At the end of the concert Moses peers inside the piano at all the nuts, bolts, pieces of rubber, sits down and immediately invents a groove that entertains the members of the audience who've also come to take a look.

3 June

Moses watches another show – this time a collaboration I've made with the composer/video artist Kathy Hinde. It includes the George Crumb piece he looked at in the Havana bar, some Messiaen, and some electro-acoustic music; also a short dance piece of mine with a backing track. He says he likes it all, particularly the Crumb – some of the effects of playing inside the piano sound like mbiras, the African thumb pianos, just as some of the John Cage preparation transforms the piano into a myriad tiny gongs, or African drums. I'm aware, though, that some of the stuff I've played is more dissonant

than he plays – South African music is often very sweet, and harmonically closed. I wonder if that'll be a problem.

6–8 June

Rehearse at the Premises, Hackney. We have three days to produce something. We stare at the two baby grands in Studio One. Moses says: 'I'll teach you *Rapela*,' and over the next two hours I struggle to master a sequence of rhythms that look very simple when he plays them, but somehow defy being written down, or being played well by me. I quickly sketch down the structure of the piece, as I don't trust my memory for the next day. I've brought my John Cage bag of nuts, bolts, screws, pieces of plastic and rubber, and show Moses various effects, which is funny and kind of mechanical at first – like teaching someone to change a tyre, or mend a puncture. Moses really likes the effects – he loves changing the sound of the piano into something altogether more complex, less homogeneous.

But the real breakthrough comes after lunch, when there's a natural energy dip. I'm depressed because I've just left my house in Liverpool for the last time; while I'm away everything will be packed and moved out, and my piano sent to Steinways to be sold (we're moving to a place in Brighton). I'm grieving for my old home, where a lot of things happened in the past seven years. I've moved house several times before, but this time it's been very hard. My daughter Miranda died when she was a small baby five years ago, and I'm devastated by guilt at moving on, leaving behind physical landmarks (the emotional ones are sculpted onto me, forever). Moses says: 'All things must change.' He's missing South Africa, he's missing his son and is, I discover, thinking about moving to London. We're both chatting and smiling, and smiling and drinking coffee. Below the surface is another matter. The combination of the rain and Old Street roundabout reminds me of the brilliant sunshine in Jo'burg when we first met, and I feel powerless to change the landscape. For the first time I feel a cultural divide between the two of us. When Moses teases me about being 'English and reserved' (we're trying to fix our rehearsal time tomorrow) I inform him heatedly that actually I'm Celtic and Spanish (this is true – I wonder if he realises what a potentially fatal combination that is).

So we sit side by side, at our respective keyboards, feeling low and just improvise for quite a while, which eventually cheers us up – it's OK, we really do speak some kind of piano language. We enjoy playing big, epic, energetic riffs and come up with a piece which Moses calls *Fast Lane Africa* – we compose the opening, an extended chord sequence for the middle, a rhythmic riff for accompaniment, an 'mbira' part – putting our left hand on the strings inside the piano, playing on the keyboard with the right – and the end. The rest will be improvised. We run it, it lasts about 12 minutes. We have another go at *Rapela* – still impossible, but at least, this time, I know where I should be in the piece. Moses

teaches me a hymn his grandfather taught him as a boy – a beautiful sequence of melancholy chords, which segue into the South African national anthem. We begin to write a prepared piano piece which turns out to be clubby and hard-edged. Decide to go home at midnight.

At the end of three days we have about 45 minutes of music; one piece, *Yakhalinkomo*, is a famous South African jazz tune; two others, *Natemoholo* and *Rapela*, are tunes from Moses's album, and have been radically reworked. The rest are new – pieces that we've written, I've jotted down, and which use American contemporary techniques with African harmonies and rhythms, some of them with dance tracks. There's a piece for prepared piano, where we race to get our nuts and bolts in between the strings. To cover this strange spectacle we've invented a marimba riff on the computer, which supposedly gives us a couple of minutes to get all the stuff in. The only exception to all this is a minimalist piece written by the Japanese composer Somei Satoh called *Incarnation II*, a powerful piece I play a lot. I teach the chord changes to Moses, then we find a reasonable koto sound on the computer and mix that in with the piano. I check with Andrew – is 45 minutes enough? He says whatever is fine.

9 June

The pianos have been moved from the Premises to the Spitz and I'm feeling homesick again. I rang my husband last night and said it's all a disaster, I'm useless and I can't improvise, and he said, well, that's exactly what you said all those years ago when you started playing with Django and Human Chain. By the way I can't find Bill (one of the cats), I think he's been packed away into a box.

When I arrive at the Spitz for a sound check a *Guardian* photographer is waiting for us, which doesn't fill me with joy – it'd be nice to really have this as a try-out gig, without any pressure. It always seems to be like this – my career has been littered with first-time performances of major pieces, broadcast live on the radio, or under the glare of television. I would like to wear a sign on my head that says, look, I really don't know what I'm doing yet – how about coming back in ten years?

As the place begins to fill up I start to feel really nervous. Classical repertoire can take care of itself, and new contemporary work is usually supported by the composer, the publishers, critics who know what they like and don't like (I can usually write their reviews in advance), and a coterie of admirers in the audience – but collaborations like this are fragile, can be misrepresented, or have no shelf life. We would like this to have a future.

We've agreed on the set list, and divide announcing the pieces between us. Only one mishap when Moses swaps two pieces round and the sound engineer puts an echo effect on what he hopes is the Japanese piece and is, in fact, the dreaded *Rapela*. Apart from that

it's a very exciting performance, with lots of new things happening in each piece. I'm really touched when Moses announces his grandfather's hymn: 'Joanna, my grandfather is your grandfather … ' I never knew either of my grandfathers, so it's very special. We don't have an encore, but the audience really loves it. We've played for an hour and ten minutes. Moses can be very reserved, but tonight he's chatting to all the musicians who've come to see us play; I think he's very pleased. He played here a few years ago in Hugh Masekela's band, but tonight is his first London gig as a soloist.

12 June
My cousin Geraldine calls to say there's a great review in *The Guardian*. I say I don't want to read it. But it's an absolute rave, she insists. I demur again, wimpily saying I don't like looking at reviews when I'm going on to play the same set. BUT IT'S A TOTAL RAVE, she says, and goodness me I'm fed up with all you artists (she's a book publisher) – if you don't think this is a good review I'm GOING HOME AND GIVING IT ALL UP. I'm duly admonished and creep round to the newsagents; it is a great review. Curiously though, when it actually tries to describe who was doing what, it gets it wrong. I was playing arpeggios while Moses was playing jazz riffs. Wrong. Moses played hard-edged be-bop chords while I was running up and down the piano. No, other way round. The whole point is that we've been swapping roles, jumping from jazz to classical, from boppy dance rhythms to stillness. Even watching us closely, somebody said on the night, they couldn't tell who was playing what. Good, I thought.

1 July
Travel to Johannesburg from Ireland, where I've left the West Cork Festival in mid-flow. I've played the complete Book 1 of Bach's *48*, and a concert of Cuban music with my friend the Norwegian percussionist Hans-Kristian Sørensen. Moses and I need a couple more numbers, I muse on the plane …

2 July
Sue Marnell from the British Council picks me up at Jo'burg airport and takes me to Wandies Place, a café in Soweto. I'm amazed to see posters of myself and Moses along the roads into the townships. When I first came to play in South Africa, six years ago, I felt uncomfortably trapped inside a white, protected world represented here by classical music, which had come to symbolise a depressing picture of the past. It's been hard to climb out. The posters of me and Moses together define that journey for me; there are risks on both sides, of course.

Over lunch I see Rosie Katz, a dynamic woman who runs the MIDI Trust (which seeks

to put music-making within reach of the whole population) and whom I would like spnm to work with. So much talent in South Africa and no resources – funding is pitiful and in uproar. I often think it would be salutary for orchestral managers from the UK to spend some time here: Johannesburg Symphony Orchestra disbanded itself, Cape Town Symphony has just been cut. None of this is surprising – they were guzzling an enormous proportion of the arts budget, and playing unimaginative repertoire to dwindling, essentially white, audiences. I'm aware of the political undercurrents in my collaboration with Moses and don't assume that it will be met uncritically.

Back to the airport where I meet Moses, who looks great – relaxed and happy. Start the long slog to Grahamstown – plane to Port Elizabeth, then a two-hour drive. Arrive in the dark; can just about make out the Rhodes University buildings.

3 July

We rehearse all day on the huge stage of the Monument Theatre at the University. Moses agrees we need a couple more numbers; he teaches me an earlier tune of his, *Kwalo*, and I teach him a piece I've just learnt from Django Bates called *Hollyhocks*. It's a typical Django piece – in 5/4 and playful and witty. Moses loves it, but we both find it tricky. The way we teach each other is always by ear – we play sections over and over again, until the other has got it. The two TV stations come and film us playing. When Moses goes for a cigarette break I start to practise the slow movement of the Ravel concerto – wildly different, but I have to play it at the Proms when I get back and slow, simple music is much more nerve-racking. Also, so much of our set is improvised that it's calming to focus on something written-down for ten minutes. Grahamstown is an easy place to hang out, a university town full of grungy bars and cafés. We retire to a pub to watch the Euro 2000 Final, rooting for Italy, and are duly disgusted.

4 July

On the stage we have an Imperial Bösendorfer and a Steinway grand, both in pretty good shape. Moses tells me he's never been given a grand piano to play on in South Africa – as a black jazz musician he's been told it's electric keyboard or nothing. Now, he laughs, he can demand a grand piano to play, as the inside has become as vital as the outside. Pianos in South Africa can be pretty rough (though there's a good one in Durban City Hall) but these two are well looked-after, and powerful.

We play to about a thousand people, black and white. Moses is considered to be Abdullah Ibrahim's successor and has a big following; although he's still very young, he's charismatic and good-looking, tall and willowy, and his stage manner is calm, almost careful. It strikes me that the stakes are high for this partnership and Moses is as determined

as I am to make this work. Our opening number is a gentle, gleaming version of *Yakhalinkomo* which steadies our nerves and gets a hum of approval. When we launch into *Fast Lane Africa*, and throw ourselves into the pianos with our mbira improvisations, the audience begins to whoop with glee; from then on, in true jazz fashion, they clap everything they enjoy throughout the set – why can't classical concerts be like this, I wonder (not for the first time). Some people actually jump to their feet to applaud *Incarnation II*. I find this a very interesting reaction – everything so far in the set has been jazzy, funky, South African, sometimes beautiful, but the very Eastern, meditative aspect of the Somei Satoh piece has really touched a nerve. We play for an hour and a half and this time we have an encore. It feels very emotional; the reception is overwhelmingly warm and vocal, with a standing ovation.

Later have dinner with Mannie Manim, a pivotal figure who founded the Market Theatre. Mannie is the new chairman of the Grahamstown Festival, and has to deal with the latest body blow – sponsorship is being withdrawn by the Standard Bank next year, after 25 years. We chat about Delysia Forbes and Marlene Leroux, two formidable (and stylish) women at Cape Town City Council whom I met on my trip there last year, who are shaping current arts policy and are simply not afraid to take some very difficult decisions. Delysia was in exile in London for ten years – she's got some great, stinging things to say about classical ballet, African dance and body image – and Marlene I met the night I played with Amampondo, last year. Both are resolutely supporting African artists and African art forms, trying to transform the big classical institutions. It's upsetting a lot of people, of course. Crash out.

5 July

Up early to go back to Jo'burg. Tough sound-check – all the wires are mixed up, no one knows what's coming out of what speaker. Least of all the sound technician. Decide to go and watch the latest news on South Africa's World Cup bid. I went to a football match the last time I was here – the semi-final of the African Cup, between South Africa and Côte d'Ivoire (4–3 to Côte d'Ivoire). I desperately want South Africa's bid to be successful, as they need the economic boost, and more importantly the psychological boost – they would host it brilliantly.

We're tired, Moses and I, but before going out on stage we talk a little about future plans. We would both like to develop this further. At first the crowd is cooler than last night – come on, I can feel them saying, impress us. But they're great by the end, they leap to their feet on the last note. Moses and I read each other more fluidly, and I notice his playing is getting more dissonant and angular, without losing the sweetness of his melodies. His playing is incredibly varied; he often starts very gently and subtly. My

playing's getting less hard-edged; I'm picking up his dreamy, loose quality alongside all the heavy-duty stuff I usually do. In an improvised set the signposts are always the same but everything else can change, which means you have to trust each other much more, and be much more alert, than in playing a scored piece. Although Jo'burg is seen still as one of the world's most dangerous cities – car-jackings, drugs, casual violence – the bar afterwards is full of creative talk and musicians taking control of their own lives. I'm chatting to a bass player who runs a jazz series in Durban (my favourite city when I first came to South Africa; we weren't able to play there this time because a huge AIDS conference is taking every available space). Moses gets deep into conversation with a woman who's come to review us for *The Sowetan* (she liked it) and grumbles to me afterwards that she must be a feminist. 'Nah,' I say, 'She's hip and together, Moses. That's how it is.' We're ribbing each other. We have another gig here tomorrow night.

6 July
I watch the live, jubilant run-up to the World Cup in my room in Melville. When the announcement finally comes, I'm practising (Ravel again) and ring a friend, only to hear about the New Zealand delegate abstaining. I'm aghast, and, like the whole of South Africa, extremely angry.

8 July
Our last performance at City Hall, Cape Town. Get up late because we went clubbing last night. The fallout about the World Cup in the papers is volcanic – the *Daily Mail & Guardian* suggests that an African World Cup should be created, as clearly the World Cup is, in effect, European. Yeah, I think they're right.

I'm becoming increasingly aware that Moses and I are locked into a tango, where one partner tests the other with a bit of fancy footwork. Occasionally he disappears when he's most wanted; cue angry glares from me when he reappears. Then I go off, to catch up with friends, or just to take a break from sound-checks and alarm calls; cue lonesome eyes from him. An over-enthusiastic *Cape Times* review has suggested we should get married, such is our empathy on stage. We're teased about this mercilessly during an interview at a local radio station. But beyond the laughter Moses is still talking about the nuts and bolts inside the piano ('I'm addicted to it').

Another difficult sound-check – City Hall is boomy and bathroomy, and up until now has only ever been used for big orchestral concerts. Once again the speakers are mixed up, and an ominous buzz comes from Moses's monitor, which takes 40 minutes to fix. Moses suggests why the monitors are humming – nasty moment with the white, older sound technician, who in effect tells him to keep out of it, until Andrew M. steps in. The pianos

are terrible. Still, the show has been sold and stage-managed like a pop concert, and the big review in the *Cape Times* has packed the place out. Moses always does t'ai chi before going on; I, more prosaically, walk round in circles. It's a good, relaxed show, and is building well, but as we start our last number, *Natemoholo*, all the lights go out and about 1,800 people gasp. I can hear Moses saying: 'It's just a fuse, keep playing, keep playing.' So we play in pitch-black, except for a few flickering exit signs, for more than five minutes. When the lights suddenly snap back on the audience cheers. We finish the performance and wrap the whole thing up more formally backstage – there are drinks, photos, autographs, impromptu interviews, as it's the end of this particular part of the tale. Disappear with Moses and a few friends, discover some whisky back at the hotel, get to bed late.

9 July

Meet my friend Elana for breakfast; she couldn't come last night, as she was looking after her sixteen year old daughter Olivia, who lost her leg and was horrifically scarred in a bomb blast on the beach here six months ago. When I tell her about the lights going out, she goes pale. 'My God, everyone there will have thought a bomb was about to go off,' she says. I feel very, very stupid because despite being close to Elana, and knowing all about the recent bomb blasts, that simply hadn't occurred to me while I was playing. The significance of Moses urging me to keep playing, keep playing, suddenly changes.

In the afternoon we fly back to Jo'burg. We are tired, of course, and also a little sad. Not every tour is as emotionally charged as this one. Before I get on the plane to London we make some plans for another tour in Europe; I can organise a recording on my label, maybe this autumn. Promise to meet soon. Hug each other good-bye.

Postscript
'The pianist, composer and producer Moses Taiwa Molelekwa, who has been found hanged at the age of 27 next to the body of his wife, was the brightest hope for a renaissance of South Africa's jazz culture.' The Guardian, *14 February, 2001*

'I cannot remember being more overwhelmed by any concert before or since than those at the Market Theatre and Grahamstown.' Craig Canavan, Star, *14 February, 2001*

writer
Lawrence Norfolk

Lawrence Norfolk grew up in London, then Iraq, but was evacuated following the Six Day War in 1967 and returned to Britain. While studying for his doctorate on contemporary American poetry at University College London, and reviewing poetry for the *Times Literary Supplement,* he began his first novel, *Lemprière's Dictionary.* It was published in 1991, winning the Somerset Maugham Award. Five years later he published *The Pope's Rhinoceros.* Both novels have attracted critical acclaim and a devoted following. They combine a generous narrative sweep with highly specific detail, and transcend frontiers of history, time and place. They have been translated into 26 languages.

Lawrence Norfolk reviews and writes for various European and American publications, and has collaborated with artist Neal White on an artwork in response to the Human Genome Project and with musician Rob Nairn on new work inspired by the music of the nineteenth-century double-bassist Dragonetti.

In this diary Lawrence Norfolk describes the process of completing his third novel, *In the Shape of a Boar,* which he had begun when living in Chicago in 1996.

April Fools' Day 2000

London. My third novel is set on the margins of history: Greece in the age before the Trojan War and Europe from 1937 to 1971, which is within living memory. Between these periods is a 3,000 year gap. This worries me. I am thought of as a historical novelist. The new book deals in those events which leave no clear trace in the historical record and which take place in the dark territory beyond our knowledge of the past. It has proved a bewildering and gruelling place to travel. Bad roads. No map.

The book will be called *In the Shape of a Boar.* It begins with the hunt for the boar of Kalydon, which was undertaken by the fathers of the men who fought at Troy. For me, that means the moment just before European history began. The second part of the book is about a twentieth-century Romanian-Jewish poet, loosely based on Paul Celan, who flees Czernowitz, Romania, in 1941 and travels to a part of Greece, formerly Kalydon, now called Agrapha (it means 'The Unwritten Places') where he becomes involved in the hunt by Greek partisans for a Nazi officer. Later he writes a poem out of his wartime experiences. It is published to great acclaim but it rests on a version of the poet's life which cannot be verified. If it were a painting, one would say it lacks a provenance. It has no history. What can we know of such events? I'm trying to write a book which will put this question honestly: a historical novel with a 3,000-year hole where the history should be.

2 April

London. Sunday is a bad day to work. Catholic time was lumpy and bumpy with Saints' Days and holidays and festivals and what-not. Now we have Protestant time which is smooth and streamlined for maximum efficiency. It lacks texture.

I want to finish a scene which I thought I would finish yesterday. My protagonist,

Solomon Memel, has spent the war in Czernowitz and in a labour camp in southern mainland Greece (the region where the original boar hunt took place). There he has composed most of the poem for which he will become famous. The ending of the poem will conflate his participation in the hunt for a Nazi officer and the killing of the boar by the Greek heroes. The book's first 100 pages have retold the myth, and the next 100 allude more or less explicitly to the double action of Sol's poem. This scene is near the end of the modern strand which accords almost, but not quite, with what the reader has been led to expect. Sol must escape from the camp and join the hunt for the latter-day 'boar'. So far, so simple. At this late stage in the narrative I have very few choices left to make. I've boxed myself in (although I know that one of the walls I've erected is false) and I want the story to feel inevitable, as though nothing but these events can now happen because this story was scripted 3,000 years ago.

The problems are expository. This section must be rooted in Sol's consciousness, and this gives me no credible narrative presence through whom to give the context in which the action takes place. This is basic stuff. Hollywood films of the 1950s used to solve this problem by scrolling a potted history down the screen: 'It is 1369 and the peasants are revolting … ' In the scene I want to write it is September 1944 and German defeats in Romania (a historical irony I would like to use, but cannot) have triggered a long-anticipated military withdrawal. Sol is in a camp on the western slopes of Mount Zygos, which divides the lagoon of Missolonghi from the site of ancient Kalydon. The geography is almost identical to that in the ancient Greek section, so that much is clear.

Nothing else is. Sol has talked in general terms about these events in an interview which will take place later but has already been reported in the book. I don't think that information will be enough. Historically, the details of the German withdrawal are

complicated, involving shifting alliances between the different groups of partisans, the abandonment of an anti-partisan campaign, some haphazard score-settling (which shades into the opening shots of what will later become the Greek civil war), and a fair measure of chaos. Sol does not speak demotic Greek and has spent a year in a labour camp. He cannot know any of this. I cannot see how to present the events of this section as anything other than random eruptions of violence. My own limited experience tells me that this is, at least, truthful. But it feels lazy.

4 April

I am swimming, but not well.

I swim fifty 25m laps Monday to Friday between 12.10 pm and 12.35 pm. I swim front crawl. The leading hand enters the water, pulls down, then back, then in towards the body, which rolls. Your head turns with it, angled so that a low wave forms in front of you. Your mouth surfaces in the following trough and you breathe. Your other hand rises, enters the water, pulls down and back, and so on. Legs: constant four-stroke butterfly kick. Nine gulps of air get me from one end of the pool to the other.

Front crawl demands concentration. Arms, legs, shoulders, mouth, lungs and heart have to synchronise, otherwise you run out of breath and sink. Quite small technical errors amplify very quickly and make things harder. Front crawl is good because it does not allow you to think about anything other than front crawl.

But today I am not thinking about front crawl. I am thinking about my editor, Neil Taylor, with whom I am going to have lunch. I am also thinking about the deadline for my book. Or, to be precise, the fifth deadline for my book. Neil is worried because he has no manuscript. The publishing house, Weidenfeld and Nicolson, is committed to putting out this book in September of this year. One can already order it on Amazon.com. I have to reassure Neil that, come what may, he will have a completed manuscript by the end of this month. I have no idea how this will happen, but this is the fifth time I've extended the deadline and I've now run out of road.

Neil, I think, will not be reassured by anything I tell him. The only thing which will reassure him is a completed manuscript. In his heart of hearts he knows everything will be fine, but this knowledge is unhelpful at this particular point in the 'being fine' cycle. Neil edited my first book in 1991 after another editor sat on it for eight weeks. We went through it three times in the ten days remaining to us, working from 8.30 am till 9.00 pm, at which point Neil would go home and I would work on the rewrites until the early hours. The next morning we would start again. I owe Neil.

On the other hand, I've been writing this book for four years. Do I really want to rush the last 30 pages to make a publication schedule? The public doesn't read the schedule,

only the book. My name is the one on the cover. And on the other 'other hand', should I be taking four years over a novel of 300 pages? It seems I've been writing this novel forever. Perhaps I would continue indefinitely unless forced to stop by some outside agency such as falling under a bus, or being crushed beneath a 50-kilo block of frozen urine dropped from one of the 747s which circle my house like reviewers, or by being told to finish it by Neil.

I think about this as I swim, badly, up and down the pool.

7–11 April

Turin. This I should not be doing. Not now. Perhaps not ever. Some months ago I accepted an invitation to the Turin Biennale, thinking, I suppose, that my book would be finished and my wife and I could stroll around an Italian city or two being artistic and buying designer lighting fittings, the lira being so weak against the pound, etc.

This is not how it's worked out. The festival is two weeks' worth of events stretched over a month. It is in chaos. Hotel reservations are lost, events disorganised, and everything is late. I should have cancelled the whole thing, but press interviews and a couple of events in Milan have been tacked on to the back of the trip. My second book came out in December last year, when I refused to go because I was supposedly finishing the current book. Dumping out of the festival means dumping on my Italian publishers, whom I know and like. The simplest course of action is not simple. So I'm here, and hating it. All I can hear is very loud ticking.

One bright spot is the presence of David Mitchell, a young writer whose work I admire. He lives in Hiroshima and is here with his partner, Keiko. We drink enough to have several more or less irony-free conversations about what we both do, which is write novels. It strikes me that it's hard enough to talk truthfully about the business of writing when one's interlocutor actually practises the subject at hand. What hope is there for a multilingual audience with induction-loop gizmos feeding a surreally inaccurate simul-translation into their ears? This the event in which I and nine other writers are supposed to participate.

The first person to speak wrote the screenplay for *Life is Beautiful*. Mister *Life is Beautiful* talks about his work for 50 minutes without stopping, then leaves for the airport. Perhaps the script for a screwball comedy set in a Bosnian rape camp urgently requires his presence elsewhere. Anyway, most of the audience takes the opportunity to escape. I don't blame them. I wish I could escape too.

Later that night I get a call from my wife. Her father is very ill and I should probably get back sooner rather than later. I'm on the next plane out.

Never wish for what you want.

12–28 April

Various places in London. My father-in-law is dying. I am very close to him. I am finishing the book. I'm not sure how these three statements can coexist. Two thousand words have to go down every day to give me a chance of making the deadline. Some days I am in my house for only an hour or two. There is no time to read anything I've done, and no point either: there's no time to rewrite it if it's wrong. The first 100 pages of this book took a little over two years to write. The last 100 have to take a little under three months. I have two weeks of that three months left. The suspicion that I'm throwing away three and a half years' work grows with every day.

29 April, 5.21 pm

I finish.

30 April–2 May

The moment when you end a long project feels like nothing much. It grows more significant in the period afterwards. 'Ending' means that certain kinds of textual operations will cease and what these might have been only becomes clear by looking back over what you've done – and noticing the mistakes. I am in the revision period. There is no time for major rewrites, and certainly no time to add any more to the text. It's cut or do nothing. Perhaps this is why I get the idea that I should lose one of the time-frames in the second part of the book.

There are three time-frames. The first runs from 1938 to 1945: Sol in pre-war Czernowitz, the German occupation, Sol's flight to Greece, his capture, then escape at the end of the war and participation in the hunt for a Nazi officer. The second runs from 1947 to 1954: Sol lives in Paris; his poem *Die Keilerjagd* (*The Boar Hunt*) is published to initial indifference, then great acclaim; a 'footnoted' edition published by Jakob, his old friend from Czernowitz, appears – and appears to discredit Sol's role in the Greek hunt for the Nazi officer. Sol's reputation is eventually restored and he is rehabilitated, but doubt lingers over his life during the war. The third frame covers a few weeks in 1971, when Ruth, Sol's lover from Czernowitz, arrives in Paris to shoot a film based on Sol's poem; Sol's relationship with her and Jakob is re-examined, and Sol's role in the hunt. The truth seems to come out although the last line twists that 'truth' inside out.

These three time-frames are intercut with one another in reverse chronology. A scene in the 1970s offers a version of events, which is modified by the version offered in the 1947–54 section, which is countermanded (or not) by the narrative of what happened during the war, which raises a question to be 'answered' in the following 1970s section. The effect is of working through the accretions of meaning (and falsehood) to reach forward

for the next incident in the story. It's not quite as schematic as that but it is quite intricate. I think I want to cut the second of these time-frames. I'm not sure why, or how to do it without the structure breaking down the middle. It would create a lot of narrative problems and, as I've decided not to fold flashbacks into the sections, there's no way to relocate the cut material into the remaining two time-frames.

3 May

Is there a word for the line of hunters which gradually encloses the ground in which the quarry is thought to be hiding, forms a circle, than advances on its centre? I read it somewhere, once.

11 May

Meeting with Neil, who has now read the manuscript. I present my plan to him. He counsels against it, with some vehemence. I argue it through with him. When I get home I see what I should have seen immediately. To cut out a time-frame is an insane idea. But I had the thought in the first place for a reason: the book's not quite right. I know this is true, and I know that given three or four weeks of reflection I could make the correct decisions. The book I want to write is present in the book I have actually written. But where?

The story in Part One (the hunt for the Boar of Kalydon, retold, plus footnotes) should be clearer. Also, there's a problem with the tonal discrepancies between the three time-frames in Part Two. They should be differentiated, not separated (they are versions of each other) and all must relate to the narrative of the hunt (in Part One, which retrospectively becomes a prose version of Sol's poem or an artefact derived from it) and the accompanying footnotes (which similarly become Jakob's footnotes). Both elements of Part One contain information which modifies how we see the story in Part Two. Each of these parts supplies the context for the other. The real meaning is always a jump ahead or behind. It's a kind of narrative sleight of hand. The point about this is that tone becomes very important. For reasons I've never understood, fundamental problems (in the narrative, or among the characters, or wherever) surface first in the tone. I think as the narrative voice lifts off the material in which it should be immersed it starts to sound shrill and needy. Miners used to carry canaries underground to act as sensors for fatal gases. In stories, the canary is the tone. It squawks and dies. The problems in Part One don't bother me because that's something I know I can fix, but those in Part Two are worrying. The difficulty might be irremediable, whatever it is. I start going over the manuscript.

15 May

Very strange. A newspaper article runs a piece on the 'rediscovery' of the Roman poetess

Sulpicia. (Never mind that Sulpicia's few surviving poems have been published several times.) I have an edition and pull it down to discover that there's a poem about boar-hunting, which includes the word 'indago'. An 'indago' is a 'line of hunters which gradually encloses the ground in which the quarry is thought to be hiding, forms a circle, than advances on its centre'. The translator explains this in a note. He himself uses the word 'tinchel', which he found, he says, in a novel by Sir Walter Scott. This is not the word I read once and have forgotten. I have still forgotten that word. 'Tinchel' goes in; Part One, page 1, paragraph 2.

19 May

There's a period in which the work you've done settles within you. The relative costs in time and effort between this or that element fall away. Your self-regard sinks. The 'parts you love' take their place among all the other parts of the book. Your criteria change. The writer of a book has no raison d'être from the moment the text is completed. But it seems to take a few weeks for the book's rewriter to strangle his or her predecessor. At the moment I'm not sure if I'm doing the choking or being choked.

24 May

All the editing that is going to be done has been done. [Later note: I will add another 839 changes at the page proof stage.] The book has to be copy-edited, a process which will be complicated by the presence of the footnotes, and this has to start now. The problems in Part One have been solved (more or less) by reversing the drift of explanatory material towards the back of the section and placing it at the front, which is where readers will find it useful. The tonal shifts in Part Two have been much harder to iron out. There seem to be a lot of different causes (implied flashbacks creating 'false' time-frames, accidents of wording seeming to know more than has so far been narrated, varying distances between narrators and material) but they all signal strain within the narrative framework as a whole. My instincts about three time-frames being one too many seem to have been right, but the structure needs re-engineering, not just cutting. I get to work on that and the tone-problems start to disappear. Two paragraphs vex me in particular, which is usually a sign that the major problem is being solved; the residual anxiety has to go somewhere.

1–10 June

Editing saves books. Copy-editing saves authors. All writers have their bad habits: words and phrases they overuse or misspell, syntactic structures they lean on too heavily. Copy editors find and eliminate them. Mine is Roger Cazalet, whom I've known for ten years and who copy-edited my last book (800 pages long, also very late). We agree that the foot-

notes (only 107 of them, but containing just over 1,000 references to Greek and Latin texts) can be checked for consistency of form, but not for accuracy. They are the main reason that the first part of this novel took two years to write. Checking them would take a full-time researcher between three and six months.

A copy-edited text is always a shock. You can't believe that there can be so many things wrong with anyone's manuscript, let alone yours. A copy editor's remit encompasses the odds and ends mentioned above, grammatical errors, errors of meaning and sense (e.g.: 'His eyes ran after her … ' Do eyes have legs?), typos, inconsistencies (always lots of these), and passages which no one in their right mind would let through because they're terrible. A copy editor produces a style-sheet to regularise the spelling of characters' names and places. In addition to all this, Roger has to make sense of my make-it-up-as-we-go approach to footnote conventions. The logical relations underlying footnotes are a minefield even when they're consistent. Mine are not. Roger works in light pencil but even so a page with over 200 marks on it looks very very bad. All my own work.

11 June

Roger has now been through the complete text. We sit down together to go through what he has found. There's a trick to this kind of work. Two imperatives have to be balanced: to maintain concentration and to keep moving. It's all too easy to spend twenty minutes arguing over a semi-colon; it's just as easy to miss the one semi-colon that really matters. Copy-editing is about due diligence. Five or six hours is the most that can be done in a day; after that you start to miss things. Time pressures have forced us to split the manuscript into four discrete parts which we rotate between us. The idea is to produce an almost clean manuscript that can be put into production immediately. For each part we follow the same procedure: Roger reads the draft manuscript, marks it up, discusses the marks with me, and then I key the changes we agree into the computer to produce a final manuscript. The fact that all four parts are always at different stages of this four-stage process (or eight; we go through the manuscript twice) quickly creates a logistical nightmare. But the book is getting better. I can see the images more clearly.

24 June

The second round of changes to the footnotes to Part One are not going to make it into the final manuscript. I'll have to add them at the proof stage. [Later note: these will be in addition to the 839 changes mentioned in the 24 May entry.] Everything else is in. I link the computer files, which have working titles such as 'Agraphos 1–4', 'Cynegeticus 001–003', and 'Sus Graphophagus Version Two Revised', and hit 'Print'.

Writing this book has been quite unlike my experience with my first two novels. Both

of those were more excessive, the language and story more baroque, with hundreds of characters and minutely detailed plots. This book is less than half the length and it's mis-led me from the start. Only now can I see the story that I always wanted to tell. There were several periods when I had little or no idea where it was going and had to continue blind in the hope of reaching familiar terrain. In situations like that, questions of the project's value are so far beside the point that you don't spare them a thought. There is only the drain of one's energy and the expenditure of effort. You give and give; a book gives nothing in return. The only consolation is that this is a problem for the writer – not the book.

25 June
My computer has crashed twice in the last 24 hours. I know how it feels. A paragraph at the very beginning of Part Two is on its very last rewrite. It's tricky 1) because the imagery must link thematically with the final paragraph of Part One (a single page, but 3,000 years, earlier), 2) because it must establish the modern idiom after the 'mythic' idiom of the Ancient Greek section, 3) because it must plant an image I want to return to about 60 pages hence, 4) because it must introduce my main narrator, who has his eyes closed while he is made up in preparation for a TV interview and so, 5) cannot see anything, and 6) because the English language is poor in both the areas of vocabulary that I consequently need most: sensation-words like 'tingle' and 'prickle' and colloquial names for the curves and creases of the face. He can feel unguents and ointments (both words are outside the range of the paragraph's idiom) being applied by the make-up girl and he can hear her movements. He can't see anything and to resort to interior monologue so early in the sec-tion is inappropriate. I need, in particular, a word or phrase for the sides of his neck when his head is tilted back. The throat would be at almost full stretch. The neck would be bowed along its length and that carries the hint of tautness that I want. But there's no noun. Hump? Swell? Ridge? All wrong. It's already the next morning: time to stop. It's a truism that works of art are abandoned, not finished. An artist's most vital relations are not with his work, but with its failures. I've rewritten this paragraph eleven times.

11 July
I handed in the manuscript to Neil at Weidenfeld and Nicolson on 26 June. Since then I have rewritten the ending again and made 200–300 minor changes. [Later note: actually over 800, see earlier entries.] I am going to add them to the proof pages, which will be couriered to me tomorrow. I am going to describe them as 'typographical corrections'.

In the Shape of a Boar *was published on 28 September 2000.*

performance artist Bobby Baker

Bobby Baker studied painting at St Martin's School of Art but has made her international reputation as a performance artist or 'live artist'. She performs solo and her work is intensely personal, comically and sometimes painfully drawn from her own experience. Her themes range from cooking, cleaning and parenthood to relationships with God. She also draws, creates postcards, devises websites and makes videos.

In the early summer of 2000 she was due to take part in a festival in East London, 'Art in Sacred Spaces', the inspiration of an Anglican priest. Churches, synagogues and mosques were the venues for performances and installations commissioned from a range of leading artists, reflecting a society of many faiths and none. Bobby Baker was invited to lead an otherwise ordinary morning service in her own distinctive way at her local church in North London.

A further five projects were in preparation as she was writing her diary. *Pull Yourself Together* was for Mental Health Week in April. Strapped to the back of a truck, she was driven around London shouting 'Pull yourself together!' at passers-by. *Box Story* is the

fifth part of her ongoing series called 'Daily Life', jointly commissioned by the London International Festival of Theatre 2001 and the Melbourne Festival. *Expert Housework* – which soon changed its name – is a website where visitors encounter '40 remarkable actions gathered from daily life and shown in different rooms'. *The Meaning of Life* (also known as *Edible Outfits*) is another mental health project that may or may not see the light of day, and she also becomes resident artist with *Time Out* as part of the national Year of the Artist scheme. *The Sermon* was to be delivered (preached?) on 28 May.

21 January 2000

Starting this diary is the most wonderful solution to my problems of making new work, the perfect displacement activity. I will write about how stuck I am and then I won't feel so guilty about doing nothing constructive. This period of six weeks with no other commitments to talk of seemed so precious but is slipping away with nothing resolved. It's so frustrating because I feel that the answers are already there in my mind but I don't know the questions to lead me to them. Resolving the questions is the answer! I lie on the bed and phone Jude to run ideas past her and then do the same with Charlotte (Judith Knight and Charlotte Aiken of ArtsAdmin consultancy). Both very encouraging, which provides temporary relief from anxiety. Decide that going to bed at 4.00 in the afternoon to listen to talking book is just not good enough. Must get up, do weekly shop, then *Fat Attack* video. Will try and resolve title for *Expert Housework* website whilst busy. Best ideas often come then. When have best ideas come? At every hour of day and night with no discernible pattern. Idea in car on way to supermarket for new title for website ... *Housework House?*

22 January

Go to see Jo (Evans) and Will and the babies. Talking about *Expert Housework* (which I collaborated on with Jo) too anxiety-making. Discuss *The Meaning of Life* instead with huge excitement and enthusiasm (because it's in the future and therefore safer?). Thinking about its being focused exclusively on the mental health sector. Driving back, think about new title for this piece, but realise I can't do the title until I know more about the content. Do my best ideas come in the car? If so, will drive round London all day. Would enjoy that. Come to think of it, I thought up all of *Drawing on a Mother's Experience* whilst driving. Have put on a pound. Must do more Fat Attacking and drink less whisky.

23 January

Sunday. Bad day. Worried that I'm feeling so bleak about the world and life in general that any work I produce will be too profoundly dark to inflict on an unsuspecting public.

25 January

Bad day again. Impossible to work until I get to the studio and start drawing. Then my mind begins to function … just about. Thinking about title for website mostly and title for mental health project. Only come up with clichés. Then on the way back I think of a new title … *The Answer*. Quite like it … bit dull? Lying in bed at night reading *Roget's Thesaurus*, generally a great source of inspiration. Investigating the notion of perfection for *Expert Housework* rather than expertise which smacks too much of *Good Housekeeping*. Or what about competition? Prefer perfection but love idea of prizes, stardom.

27 January

Day out with American sister-in-law. Lunch, shopping for bras and make-up, Tate Gallery, dinner and film, not in order of preference. Feeling so high. Mind dwelling on bundle of problems all the time and rolling them around with relish. Then in the Tate read plaque next to sculpture of Pandora. Had overlooked Pandora connection with *Box Story* as I had been so intent on altar, coffin, death theme. 'In Greek myth, Pandora was the first mortal woman, created by Vulcan … he gave her the gifts of beauty, the power of song and eloquence. Zeus gave her a box containing every human ill and sent her to Earth. When she opened this box all the misfortunes that have since afflicted mankind flew out. The figure of Pandora, the original temptress, was often used in nineteenth-century art and literature as a vehicle for ambivalent feelings about women.' Love the bit about misfortune and the misogynistic slant. Sharpens my focus on what the stories will be about. *The Answer* too simplistic. Needs questions too or more perfect title. Neatly put that on list of problems to be solved. Productive day. Should go on outings all the time or become a taxi driver.

29 January

Struck down with despair. Struggling to think about projects but they all feel hopeless. Utter negativity. Will phone Jude on Monday to cancel everything except *Pull Yourself Together*, the only appropriate show in my current state of mind.

30 January

Great news! Jocelyn Pook has phoned to say she can compose the music for *Box Story*. Immediate celebration and change of mood. Would probably have scrapped the whole thing if she couldn't do it. Move straight onto *HouseWorkHouse* (definite new title approved by Jude).

31 January

Spend day drawing and reading thesaurus. Get nowhere except to make long lists of words appropriate to each project. Pol (Polona Baloh Brown, best friend, co-director and collaborator for ten years) asked me to do drawings for *Box Story* but can only draw fat me.

2 February

Andrew (husband) ill in bed so work in studio and look after him. Beautiful day. Bulbs sprouting everywhere. Spend morning on the net looking at colours. Why do most website designers ignore the fact that computer screens are essentially grey? Why the preponderance of beige when they look so dreadful together? Get strong ideas for colours I want

us to use. Suddenly remember a whole bunch of faxes of film ideas I sent to a director three years ago. Wonder whether there's anything relevant to now. A pot of ideas! Most of it is directly related to *HouseWorkHouse*. So exciting. Obvious now that idea started as film but has transmuted into website. So many ideas forgotten about. Discover one entitled 'The Woman Who Mistook Her Mouth for a Pocket': perfect for *The Sermon*. Mind explodes with new ideas. Can't stop laughing. Particularly like idea for pen clipped into mouth like pocket. Frantically look round house for pen that will fit lip. Can't find one. Dubious about going to stationer's to try out pens in mouth. Have to do Fat Attack exercises to calm myself down.

9 February

Consumed by all these titles, problems, questions. The problem is that there are too many problems. Resort to washing duvets to keep mind at bay.

10 February

Go to see Jo to talk about *HouseWorkHouse*. Tremendous help, huge improvement on yesterday. Just the process of explaining my ideas starts to clear the confusion. Everything seems to have come on quite a bit since we last spoke. That is what I'm missing at the moment. Normally I would be meeting Pol from time to time and talking things through. Can't wait for her to get back from Slovenia. I'm very excited about the mental health project. I'm listening to all the conversations round me in a constant search for a new title. It might pop out of someone's mouth and I mustn't miss it. Latest idea is *Shopping Trip*.

11 February

Meet Jocelyn Pook. Great talking about *Box Story*. Very positive about working with her. Discuss the way the music intertwines with the performance, a real collaboration rather than just tacking things together. She suggests the Hilliard Ensemble as a choir we might have. They want to work with her. Does it matter about them being men when I'd wanted a female choir? Odd how my mind starts to waver at the suggestion!

13 February

Ever since meeting Jocelyn I've been constantly thinking about stories for *Box Story*. Every story I hear, or memory I have, becomes a possible model. It's the theme I can't pin down. Keep on getting snatches of ideas, like one of putting a glass on my head and trying to pour wine into it while chatting to the audience. Also thinking of the story for *The Sermon*. I will be constantly putting things into my mouth (pocket) and taking them out, distorting my voice. Will the joke wear thin? The story is central in all these shows.

20 February

At Essex University for a two-week session with a group of MA Contemporary Theatre students. (Lots of driving involved.) Students are great but I am almost crazed with the desperate quest for solutions that is going on in my head. I can't stop searching but feel I'm getting nowhere. So glad Pol is back soon. Perhaps the problem is that I'm working on too many projects at once? Resolve to work on one thing at a time. This next week it will be *The Sermon.*

21 February

Yesterday's decision to concentrate on one thing at a time proved very successful. About an hour after taking that decision I sat down on the sofa and, almost in front of my eyes, a scenario for the sermon played itself through. I laughed with enjoyment especially at the bit where I climb into a towelling bag and take off my stained overall ready for washing. It was a huge relief after so much confusion and I must discipline myself to carry on with it. (A day later I'm not so sure I've got the nerve to undress in front of the congregation, even safely inside a bag, in the middle of a church service.)

5 March

Still constantly searching for a new title for the mental health project in every conversation. Drive myself half crazy listening to Radio 4 for a couple of hours and considering several thousand possibilities. Have also been considering the sermon in fits and starts. It's coming on quite well. I imagine acting it out and then the scenes just evolve before my eyes. I imagine how exactly I will say the words and what my general demeanour will be. After I've worked out a section I stop and put it away until the next time it comes to the front of my mind. I usually flag up a problem to be solved, put that away and hope for the best. I've decided not to worry about *Box Story* until I've talked to Pol.

8 March

Feeling fragile but working on the website helps. It's great with Deborah (Deborah May, film-maker and website designer) and Jo. The decision-making process is equitable. I have a way to go in understanding the technology but it's exciting. Search for a title increasingly compelling. Coped with a meeting yesterday by turning every phrase into a potential show.

12 March

Much better. Great week with the website. It's interesting how technology informs the creative decisions. Deborah has come up with a great solution for transferring my drawings

of the house. Pol is back and we start work this week on *The Sermon* and *Box Story*. Feeling very positive about it all.

19 March

Slightly confusing week. Still so many conflicting ideas going on in my head. However, great breakthrough with the mental health project. Suddenly realise that the whole thing is becoming too epic. How about starting it as a research project, on a small scale? A whole series of activities based round an edible fashion parade then come to mind. Modest but manageable. Huge relief to get that one off my mind although I shall probably still go on searching for the perfect title as it's become such a habit. Pol back from Slovenia so have first working meeting with her for ages, which is also a relief and great pleasure. She likes the ideas for *The Sermon* very much but points out that I haven't got an ending. Am very worried about this. It is extremely difficult to know how to proceed in such a sensitive arena, i.e. a real church service. Pol very constructive, suggests working on one stage at a time. This week's work is to try and resolve what it is that I am trying to say. Rather daunting! Had a long talk about *Box Story*. She thinks that I'm worrying far too soon about the whole thing as we actually have ages to go, and she also points out that I am always confused and negative and think that this one is the worst ever! Also masses to sort out for the website and a workshop performance this next week. Have abandoned *Fat Attack* and resorted to the gym again due to boredom. Always think I'm going to resolve important problems while I'm exercising but never do.

27 March

Excellent week. Big leaps and bounds. Difficult meeting cancelled at last moment. I feel like I've been let out on bail. The result is a surge of new ideas. First the mental health project has become a fully fledged two-year plan entitled 'Edible Outfits' involving workshops, fashion parades, a book, a film and a website. Next, I've resolved a crucial element of *Box Story*. Deciding I can repeat the drawing idea from *Drawing on a Mother's Experience* I go through whole streams of ideas until I'm in a supermarket and see a collage of food on a package. One idea and image lead to another, and at one point I am leaving a meeting on my bike when I suddenly think of mapping. I am so excited that I nearly ride under a bus. Still finding it impossible to concentrate on the ending of *The Sermon*, ironically the most pressing problem.

9 April

Meeting with Pol about *Box Story* and *The Sermon*. She approves of new ideas, which is a relief, and while I am telling her all the different endings I've been thinking about the

whole thing suddenly goes a stage further, culminating in a definite new image. She likes it as well so that seems to be that. Must get on with it but am quite caught up with preparing for *Pull Yourself Together*. New plan to give up dieting and spend time eating and exercising. Quite exhausting.

16 April

Sunday is my regular diary day, the only time I get a chance to reflect on things. Great time on Thursday when I had ideas for two new shows. Well, one was a bit over the top. I was driving along and saw three old ladies chatting on the corner of the street. I immediately thought of stationing three old ladies on the corner of every street in a given area (actually I thought of the whole country initially) so people could wander up to them and have a chat. There's a lot missing to the idea and the pragmatics are somewhat daunting. Never mind!

The other idea surfaced when I was Fat Attacking for the first time for ages and I'm so pleased with it that I can't write it down in case it gets spoiled, but it's a film, postcards, a book and a website – of course! Pol's set me the task of working on the sins I'm going to use in the sermon but it's an effort to focus on it. We both go to church this morning to consider the practicalities.

1 May

Weekend in Dorset. There's been a lot going on. *Pull Yourself Together* turned out to be a fabulous experience with great responses. Time-consuming though. Am definitely going to take on the *Time Out* Year of the Artist residency, although there is a worrying overload of the system. I've got to come up with something for the award ceremony on 5 June but think I'm going to develop an existing idea to do with symbolically eating the judges. Then I've got two or three months to think up a new idea for the rest of the residency. As usual, very excited when something is first proposed but panic when it dawns on me that I'm actually going to have to do it. My idea of bliss: to be expected to come up with endless new ideas but never to have to realise them. Is this true? Probably not, but it's a nice thought. The thought of raising money for *Edible Outfits* and *Box Story*, for instance, is so lowering. Went for a walk along the Dorset cliffs yesterday. Vertigo set in so I distracted myself by thinking about *The Sermon* instead.

7 May

Completely stuck. Can't get on with *The Sermon*. Unable to concentrate on *Box Story* or the *Time Out* project. Have resorted to hammock-swinging and water aerobics as displacement activities.

14 May

Glad to be back working on the sermon properly now with Pol. It will start with the pocket-as-mouth notion and an exploration of sermonising and lead on to the real subject – sin. It goes back to my original experience of church as a place where you are made to feel guilty. My text will be Jeremiah 2:22. 'For though thou wash thee with nitre, and take thee much soap, yet thine iniquity is marked before me, saith the Lord God.' I'm fascinated by the imagery of washing and stains – dirt and the unmentionable – and its connection to evil.

29 May

Find it impossible to write about the process of making the sermon while the intense phase is in progress, only partly due to being busy with it, preparing for the *Time Out* piece and writing the application for *Box Story*. It worries me that my idea is so transparently simple and yet I can't see any other way of structuring it given the extraordinary problems of performing during a real live act of worship. I have to contend with the existing congregation and their expectations (whatever those are) and the visiting public and their relationship to the piece as a work of art. Also possibly a great antipathy from the visiting public to the church, especially towards the sort of illiberal imagery I am playing with. It is like balancing on a knife-edge. I could never have done it without the good-humoured and generous compliance of the vicar, Dave Tomlinson, and Fraser Dyer, one of the church wardens, who is leading the service. When I describe the sermon and the sort of hymn I am looking for (I am choosing the hymns and all the texts for the service) Fraser comes up with one starting: 'There is a fountain filled with blood drawn from Emmanuel's veins.' General collapse in hysterical laughter. It is perfect imagery to set the scene – Gothic horror, serious side, how imbued with a sense of guilt we are, how to examine the roots of all that shame.

I'm reticent about coming up with personal sins, but this is blasted away in a great session with Pol. I suddenly remember an incident when I was driving down Holloway Road and, in a distracted moment, swerved onto the other side of the road and almost crashed into a car coming in the opposite direction. It swerved towards me at the same time. I was filled with rage and leaned out of the window waving two fingers at the driver. At that precise moment he leaned out and did the same to me. In a blinding flash we recognised each other … it was the vicar. We decide to use this story for the sin of rage and the rest of the examples follow on from there. A fine little bunch of confessions, each teetering dangerously close to the brink of embarrassing revelation, but to be delivered in such a way as to engage the congregation, spark off personal memories, tease their sensibilities, shock, amuse and entertain. We work on how to put it together so that each bunch of sins links to a particular stain so that while I am telling the stories I will rub different food-

stuffs into my overall – ketchup, mint sauce, mustard. The stains/sins have to relate to each other in an intricate construction so as not to be cloying.

Once I am covered in sin there's a technical problem. I am to climb into the towelling beach-bag I've made in order to remove the stained overall in suburban decency. The bag has also been designed so I will resemble a priest in vestments. Then I am to emerge in a clean reconstituted overall later in the performance. The trouble is that the 'sins' rub off on the inside of the bag and will stain the pristine overall, destroying the final transforming image of cleansed absolution. Hasty consultation with the costume-maker gives us the idea of a lining which can be surreptitiously removed during the performance. I always get worried when technical hitches occur that the whole idea is flawed, that there should be a delicious simplicity to the construction of images. However, in the event it all works like a dream.

After taking off the overall I am to cut it into small pieces and put each piece in a different stain solution in a set of bowls on a table. I am building on an image of an overall impregnated with foodstuffs dried and encrusted – years of stubborn stains/sins to deal with. The problem is how to get from these soaking fragments to an overall reconstituted with hundreds of tiny, perfectly clean patchwork pieces all sewn together. We eventually decide that the washing image can be told as a story – that I can take people on a mental journey to my laundry room. I love those sections during a performance when you endeavour to conjure up a sensual image of an experience and then debunk the whole thing.

But how to tackle the next, crucial section, after the fragments have been got out of the washing machine and hung on the line in delightful, regimented order? How to indicate the range of possibilities of what happens next? I don't want to refer directly to divine intervention. I've already tackled absolution in the stain-slaying but I want it to go further, and be a reflection on a whole range of ideas to do with human frailty. Rather than prescribing a set of images I want the congregation to be able to take it in many different ways using religious or secular concepts, and to reflect on the divine in an un-bigoted way – a definite challenge. We discuss a range of possibilities but I just can't put it together, and then, one night just as my head is dropping onto the pillow, a single word comes into my mind, SILENCE. It turns out to be the pivotal moment in the sermon. I am to stand on the chancel steps and say: 'This is the moment when words simply fail,' and then stand in complete silence for a whole minute – a long time in a performance. I am to fold my hands in a devout way and gaze at the stained-glass windows, occasionally taking a peek at my watch to indicate my human frailty in needing to keep control of the time at such a solemn moment. Then it will be simple to turn back to the altar, remove the lining of the bag and put on the clean patchwork overall. At that moment the music is to start. I

have a struggle choosing between religious and secular, taped or live organ music until I remember ABBA. The thought of dancing in an ungainly way up and down the nave in a scrappy overall just cracks me up. It debunks so much of the imagery and, hopefully, raises so many questions. I play *ABBA Gold* for hours before selecting 'Thank You For the Music'. I practise the gawky dancing on my own in the kitchen every night after several glasses of wine, roaring with laughter. I'm embarrassed to admit how much I revel in key moments of performance by myself.

On the day we are well organised. The congregation is welcomed with carefully pre-pared service sheets. Flowers are arranged. The organ is playing. With the church packed full, Dave, Fraser and I walk to our chairs from the vestry. The whole service has the solemnity and attention to detail we've worked so hard to establish. There are hymns, prayers, parish notices and finally the texts. First Jeremiah 2:19–26 (including the key verse) and then a reading from the Biotex Stain Removal packet with its references to blood and mud. Suddenly ripples of mirth pass through the congregation. And so I begin my sermon. It goes really well. I ad-lib a lot, which is always a good sign. Odd to hear roars of laughter during a church service. Several press photographers have sneaked in, against our wishes, and one bobs about in front of me taking pictures. After a withering comment from me he sits down for the rest of the sermon. The silence works particular-ly well. What especially pleases me is the poignancy of the event. I hadn't anticipated that. After my wild dancing I go quietly back to my seat. There is a silence again. I had want-ed the service to continue as normal then, but after a pause loud whistles and applause break out. All very strange, given the context.

1 May
Very difficult to plunge into the *Time Out* piece immediately afterwards, and write the application for funding for *Box Story*. Sense of impending collapse.

9 June
Time Out piece goes well although there is a bit too much crisis management for comfort. The title is: 'To bring a sheep to consciousness we must eat it, therefore to bring the judges of the *Time Out* Eating and Drinking Awards to consciousness we should eat them.' The idea is to make 250 biscuit images of the judges and hand them out to participants in spe-cially designed and printed boxes. It all goes pear-shaped when the biscuit dough refuses to work. Three batches crumble to pieces. I remix the dough and get it done at 2.00 on Saturday morning. My hands are swollen from the effort. Luckily Pol is there to help with packing them and the display panels but we only just get to the hotel where the event is being held in time on Monday morning. The show took place at 12.30 pm and the

Box Story application is handed in by ArtsAdmin at 5.30 pm. Next time I'll try pacing myself ...

22 June

Sitting on the beach at Paxos, reflecting. Wishing I'd worked harder at Fat Attacking. Can't stop thinking about *Box Story*. Every story I hear is a potential candidate for the show ...

The funding application was successful. The website was completed and can be found at www.bobbybakersdailylife.com.

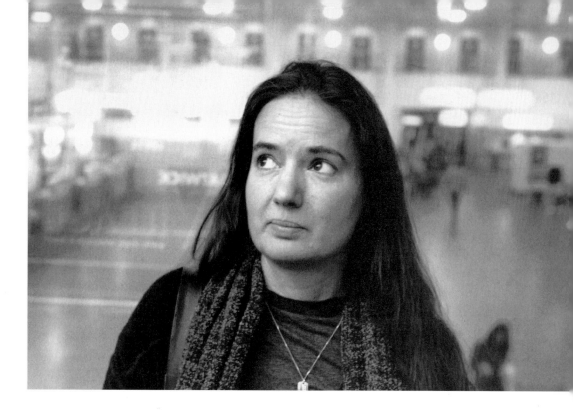

poet
Jo Shapcott

Jo Shapcott was born in London, studied at Trinity College Dublin, Dublin College of Music and the University of Oxford and was awarded a Harkness Fellowship at Harvard. She is the first poet to win the National Poetry Competition twice, besides the Commonwealth Prize for her first collection, *Electroplating the Baby*, and in the autumn of 1999 she won the prestigious Forward Prize with her book *My Life Asleep*. Her selected poems, entitled *Her Book*, were recently published by Faber and Faber. She has co-edited anthologies of contemporary poetry and, besides leading a multitude of writers' work-shops, she has been involved in the creation of many imaginative music education projects. She is Visiting Professor at the University of Newcastle upon Tyne.

During the period of this diary Jo Shapcott was Northern Arts Literary Fellow at the Universities of Newcastle and Durham, began writing a column on computer games for *The Times* with fellow-poet Don Paterson and was preparing to be Poet in Residence at the Royal Institution from the autumn. She also presented the *Poetry Proms* for BBC Radio 3, recorded at the Serpentine Gallery in London in front of a live audience of music

lovers and broadcast on radio. Then there were the usual appearances at poetry readings. Her principal project, however, was to finish a book of 'responses' inspired by poems written in French by the Austrian poet Rilke. This longstanding obsession began with a sequence called 'The Windows', which she included in *Phrase Book* in 1992. The new book, to be called *Tender Taxes*, is published by Faber and Faber in 2001.

9 February 2000

Rilke's French poems have always intrigued me. Maybe because in them he's working in a language that's not his own. There's an appealing lightness, a frothiness almost, that appears when he's away from the German. The French poems are not right at the centre of his work, though still fascinating, and offer a special freedom because of that. I can't imagine mucking around with the *Elegies* in quite the same way. In *My Life Asleep*, the last book I wrote, the Rilke sequence is called 'Les Roses'. He wrote 27 tiny rose poems and to him they represent, I think, 27 different lovers or even 27 different sets of female genitalia. He addresses the roses in his poems, calls them 'you' and 'O rose'. I've turned it round, given the rose – a traditional male image of the female – her own voice. Each one is, in its way, a small argument against the original Rilke version: 'No, it's not like that, it's like this.' But they're still, above all, a sequence of love poems or, perhaps, one extended love poem to Rilke himself.

'The Roses' are going to be at the centre of a whole book of these – translations? versions? takes? – none of these words are quite right – my poems are more like arguments with the original. The poet Basil Bunting's word for it was 'overdrafts'. The startling thing about the way the book is developing is that the poems are entirely new. Rilke even appears as a character in some of them. When you set each poem beside its Rilke original

the effect is, I think, of a discussion – a tussle between intimates – rather than one poem being a translation of its counterpart. I wonder what he would have thought?

13 February, London
Had a meeting at *The Times* to talk about the computer game column. The column itself is a first: an attempt to place games in the context of arts and culture. The editors are keen to make this column one that will change the way we view games, will give them the cultural importance they're due. They want us to broaden interest in games, to get them out of the teen ghetto and into the arena of the educated public. It's not enough just to rubbish existing games; we need to recognise their technical achievements and their own peculiar beauty, as well as their limitations. Given the infinite fluidity of the form, the appeal of PC gaming is bound to become broader as both designers and punters (they have to collude in this, which is where we come in) realise the PC game is potentially no more or less a game than the novel or the film. The situation at the moment's a bit like having the whole Hollywood infrastructure in place but only hiring cartoonists to write the scripts. On the other hand, when the game designers do get it right, e.g. get Barrington Pheloung to write the score, they don't receive sufficient credit.

My hopes for this are that we can have fun, write some exciting and even visionary stuff, and be free to follow whatever direction we like. I love the idea of banning the word 'game' from the column. I'm certain that if what we write is good, they'll use it. Above all, if it's not cheeky and subversive, I don't want to play. I catch a whiff of pure joyful angel shit at the thought of our column, immaculate, visionary and beautifully written, emerging out of the Murdoch organ (as it were) to puncture hardened Notions about Culture, high or low, including Notions which are, it has to be said, held by many of our friends

and colleagues. Ludic poetics. Let's make it a glorious lob from left field. I am working on a reading list for myself of things ludic.

15 February, a European city

Poetry readings offer a great chance to meet fellow poets, audiences and readers and are generally an excellent thing. I have been doing one every two or three weeks. This is an account of a rare nightmare. It's a bit long but hold onto your hat for the end.

The first part of my recent trip to XXXX to read at the XXXX Festival is all standard bad poetry reading – 7.00 am flight, which means taxi fare I know I won't get back, to airport where I am met by surly Bloke who talks all the time but into his hands-free mobile phone and not at all to me. He takes me in white van to dodgy part of city on the wrong side of the station and tells me he will return at 6.00 pm. He has thrust into my hand a crumpled leaflet about the festival – in a language I don't understand – so I continue to know little except that my friend the poet Archie Markham will appear the next day. I hang around hotel and snooze away early start. Bloke returns somewhat after the appointed time and whisks me away in white van.

We arrive at a huge disused slaughterhouse complete with all its hooks and intricate pulley systems intact. A stage has been erected and is stuffed with technical equipment – sound, hi-fi, props, all sorts. Loads of people bustle around but few respond to my efforts to chat. Much complex rehearsal is going on. So I wander about the slaughterhouse for a bit, feeling spare. The reading starts at 9.00 pm. Still no one talks to me. I find a small bar set up in an old animal pen and buy myself a beer. Still no talk. At about 8.00 a friend who runs a museum in the city arrives with a kind man from the British Council, who refers to her as Mrs Museum. Hooray! Friendly faces. They buy me more beer. Things are looking up. At 9.00 there is no sign of an audience. More important, there is no sign of my translator, who is supposed to appear with me. A postponement is announced. The gig will now begin at 9.30.

Eventually I am herded on stage with several others. Still no translator. First act: small bald man with three sheaves of paper, each sheaf yellowed to a different shade depending on age. Only a small part of audience leaves.

Next act. Film by woman. Seems to consist of a selection of random images with a recording of her voice intoning poems over the top. After ten minutes she walks funereally towards the screen and sits at a table in front of it so that her shadow appears on top of the random images. She begins to mouth along to her own poems deliberately out of synch. She takes out a very large rubber glove, the rather nasty see-through yellow sort, puts it on and makes mouthy motions with the floppy fingers to coincide with recorded voice. A small shadow of her hand – I like to think it was a friendly rabbit – is projected on screen. Quite a lot of leaving.

Next act: a skinny but loud rap poet who bounces up and down on the spot while shouting in German. More leaving.

Next act: man in bad suit reciting by heart with some feeling. Ends his act by holding up a dollar bill and burning it. Daring or what? More leaving.

Important note here. I like multimedia and performance art. I like avant-garde poetry. It's only bad art I don't like.

Next, me: organiser shoulders me away from microphone and talks rapidly to audience. Nice Mr British Council creeps on to stage to tell me she's explaining that my translator hasn't turned up. She has asked him (Mr BC) to translate my poems as I go along. Fortunately, he refuses. The compromise is that I am to give long introductions which he will translate. Read only four poems – an all mad cow programme – which by now suits my mood (a sequence of poems in which I personify a mad cow). More leaving.

Next act: a couple. A young woman who's a first year PhD student, and her rather older and somewhat raddled male partner. She's the only person I've talked to a little beforehand when she was kind and friendly. She's first and reads a long poem about the way women are seen as exotic sex objects. Meanwhile a mildly pornographic Japanese film is playing behind her. It's a cartoon featuring a Japanese prostitute in schoolgirl outfit with glimpses of white cotton knickers. And English subtitles. For her second poem she asks for help from the audience. She wants someone to sound a rape alarm at intervals during the poem. No one volunteers. Because I've talked to her and feel a bit of sisterhood, I jump on stage right next to her to help. She gives me the rape alarm. I'm to play it at will on any words in her ten-page poem that seem to call for it. I'm all ready. I notice she's got two microphones. One at head level and the other set low as if for guitar playing. She sits down on a chair, and her partner pops onto the stage and whips off her knickers. She inserts the microphone into her snatch and reads all ten pages in this position. I play the rape alarm with great concentration. It's probably my finest performance ever. Cartoon porn is still playing behind us. Oh, I forgot to say. Whole thing is being videoed so somewhere in the world is a film of me playing the rape alarm next to a woman reading a long, long poem with a microphone inserted in her privates. Leaving accelerates.

Next act: her partner sets up a DAT recorder so that it tapes him live on a loop. His phrases are repeated and overlap – a bit like Steve Reich only not as good. His first phrase goes like this: 'Things become more meaningful when you put your finger in my arse.' Repeated again and again. Imagine. Once he's got this little riff going on the tape, he seizes one of the props on stage – a small wardrobe – and starts hurling it around, trying to break it up. Because he's not that young he gets a bit puffed and needs frequent rests. Eventually it's starting to look a bit battered and he returns to his tape to set up a new riff: 'I wanna fuck my brains out and have an orgasm to destroy the world.' Again and again.

Imagine. This time he attacks a metal filing cabinet, pulling at the drawers and making louder and louder noises which are also recorded and repeated. Mrs Museum, sitting next to me, has by now lost the plot and is snorting into her hankie. Next, he pulls out some drugs gear and shoots up on the stage. At this point, nice Mr British Council puts on his jacket and ushers me and Mrs Museum away; we hear his louder and louder noises way into the adjacent streets. They take me for food, drink and recovery. In the morning, although I'm supposed to stay and do another gig, I run away to airport and fly home even though I have to buy a new, expensive ticket to do so.

This is all true. Do I now hold the trophy for the World's Worst Gig?

6 March, Wales

Today I'm looking at a Rilke who's in an absurdly pastoral mood (in the *Valaisian Quatrains*). Countryside, hills, vineyards, fruits, and always the essence hovering around the peaks. What might contemporary pastoral look like? Is it possible? The countryside reeks of so much other than beauty and transcendence these days: pollution, BSE, suicidal farmers, low-flying RAF fighters. I'm struggling, because though I have my own landscape in abundance here in Wales to overlay Rilke's, and though I find it infinitely healing, sad and beautiful, I still can't find the twenty-first-century door into the pastoral.

Mind you, the plague and the pox have always floated in on the pastoral air. I think Rilke's trying, in his poems, to recreate Eden before the Fall. His letters give a darker picture of his time there and his response to the landscape but the poems, well – a lot's missing. As usual, I'm tossing them around like pancakes, hoping they'll land in one piece and the right way up so that I can fill them with something entirely different. Here are two.

GWAITHLA BROOK

I'm always cladding myself
in what's just undressed me;
even my own body's a laugh,
every cell a round, rude wavelet.

So I change my outfit,
even my long hair, my skin.
Behind this kind of flight, my life
ripples, totally see-through.

You'd be arrested – stopped
halfway between earth and sky,
caught drunk in charge,
on voices of water, bronze, beer,

wrong footed on a slick of oil –
if you didn't warm your hands
on this border country, touch
its crust, finished, like bread.

11 March, London

I've just had an unusually fierce and mean piece of reviewing, with no more rationale to it than name-calling, really, and in a tiny magazine. By a bloke, of course. My policy with reviews, good and bad, is to read as few of them as possible on the grounds that you can be led astray either way – by misplaced praise as much as by damnation. Should have stuck to my own rules because, ouch, this one hurts. I instantly wished I hadn't read it so go to play a bit of Tomb Raider. There's nothing like machine-gunning a few thugs with that great girl Lara to raise the spirits at times like this. To bed to sleep on it all.

12 March

I have just checked out the latest edition of *PC Gamer* which includes a useful free wallchart – 'The Complete History of Games 1962–2000'. (I can't believe I'm actually writing such a thing down – I am now an official Nerd. Goodbye poetry.) But what is this 'frag' word I find dotted around the magazine? Damn. I am behind, in the language of gaming anyway, despite my two high-speed digital lines arriving Friday.

Yesterday I reviewed Sylvia Plath's journals for BBC Radio 4. They are very, very long indeed and nutty as a fruit cake. Beautifully written. The early part of them especially so, where you can see her using the journals to practise writing. And she's truly good, even as a teenager. A mundane scene, the young Plath sitting in a car with a boyfriend, is transmuted into glorious prose until the whole thing becomes luminous. Later, it's more painful and the writing, somehow, not as interesting. I don't know what I think about the publication of these diaries. I don't want the wondrous poems forgotten in the midst of all the prurient interest.

20 March

Don and I are just starting to e-mail bits of the first column to each other. We have written together before, using e-mail and phone. It's going to be interesting to do the same for this – perhaps even writing some of it as a conversation – when questions of gender-appeal, politics, etc. produce a difference of opinion.

21 March, Newcastle

My students ask each other today whether there is any form of language not suitable for poetry. Good discussion. I tell them about my poem 'Spaghetti Junction', which is based on a German poem by Enzensberger. I like particularly what he does with time: how everything loops and replays in the muddled mind of the accident victim. I home in on my favourite arena – how the fallible or broken can perceive differently, more accurately, maybe.

We also talk about vocabularies. I tell them that my first effort lost all the car-i-ness of Enzensberger's version which sounds much more spicily technological in German. So I scoured a load of motoring magazines and imported great gobs of the secret language of car fanatics into the poem to get some of that feeling back. I love the many different languages we speak – whether football, quantum physics or hairdressing. They tell so much about boundaries, power, politics. I loved discovering that 'stonking' is the single favourite word of the motoring journalist. For private fun, I mirrored Enzensberger's syllable count in every line.

29 March, East Coast Line

Listened to Evensong on the train from Newcastle to London just now. The reading quoted what Joseph said after Pharaoh had raised him up in Egypt and given him power, wife, children. He spoke these words after the birth of his second son: 'Because I have been fruitful in the Land of my Suffering'.

19 April, London

Just finishing the first computer game column. Have had good fun to-ing and fro-ing with Don all week. A laugh. But, as Frost has it: 'Play for mortal stakes.' I think our editor is excited about the idea of working with poets. He doesn't realise it's the end of both our poetry careers. Off to Wales tomorrow. My shed at the end of the garden. The importance of a retreat to any writer.

24 April, Wales

Eeek! Just seen myself in *The Times* (on-line version – I don't think we'll get out to a shop

today). Not sure about the photos, but I think my co-writer looks quite stark staring mad in all of them and I take some mean consolation in looking slightly more together than him.

11 May, Newcastle

There has been a traumatic moment, an encounter with a large bee. It flew into my office yesterday, and was so big – one of those huge fluffy round ones, about the size of a £2 coin – that I didn't dare tangle with it and left the window open hoping it would fly out. I dropped by the office early today and as I was sitting at my desk, noticed a sort of vibrating sensation round my ankle but very vague, as if I were on a pavement above an underground train. Strange, I thought. Five minutes later I felt more vibrations, much higher up, and a distinct large fluffy mass. Did I scream? Did I pull my trousers off faster than I would for even Jeremy Paxman? Such is the University of Newcastle that no one came to investigate despite the fact that my screams were ear-piercing and the corridor was crowded. Probably just as well: the sight of a dancing, screaming, trouserless professor would not have been an edifying one. I now have a very small bee-sting for such a large beast, on the tenderest part of the inside of my right knee. There's a German poem by Rilke (funnily enough) about just those most vulnerable and lovely parts of the body – inside elbow, nape of neck, etc. It's called 'Handinneres' in his version, meaning, inside (interior, deep down) of the hand. I haven't got it right yet, so I was glad to be reminded when I looked it out this morning. It's still provisional. Shapcott's version of Rilke:

TENDERFOOT

He's as close as the inside of my own hand,
here, this palm, my old sole, ex-foot
whose new version of walking is feeling.
He tries to hold himself up
by a number of means,
the mirror, for one, which he scans
for the streets of heaven behind him
bleeding underfoot.
My palm walks on water
when it cups water,
when it cups his face,
when it wanders into his hands
and makes a countryside of them,
fills them with arrival.

I've been mulling over e-mails; how important they are to us already. They are a form of writing and so naturally for me a form of art too, all the many sorts of e-mail writing but especially what whizzes out of my machine, because I've become a much better correspondent with this new medium. I'm fascinated by the different conventions – or identities? – applicable to all the messages we send out. A rich but confusing mixture.

In the days when folk wrote letters, they were helped by an understanding of what a letter was, what it did, who it was for. A series of conventions helped them to express an emotional and practical repertoire which, in general, fitted into the expected epistolary shape, and into the social norms as well. The letter of complaint to the gas board would look one way, and a love letter another, but you knew where you were and how to do which. And that would even be true of famous literary letters, I think, which flowered within those shapes and conventions. You knew how to define yourself – even your many selves (gas board customer, lover, parent, and so on) – through the well established, well understood form of The Letter.

Trouble is, with me the act of writing makes identity fall away in fragments. So the words are all either underdone or overdone in response to the category of writing I'm engaged in. I can't help being aware of the genre – as in these diary pieces – and what its technical demands might be. So I am not sure how much of myself survives the electronic transfer. My poems are the only place where matter takes shape during the act of writing. But it should be perfectly possible to send words in published prose, or through e-mails, letters, diaries without feeling that the expression and the identity slide away from each other.

There's something about the electronic medium which exaggerates the fragmentation. Hell, we even have different mailboxes, different 'addresses' – which are actually different names – to send and receive our different modes of discourse. I've got loads but not as many as one of my poet colleagues who's made the mistake of having one for each girlfriend, one for each project; a life so split he's lost himself altogether.

Fragmentation. Multitudes. We are all many things to each other at the same time: children, parents, colleagues, poets, friends, lovers, correspondents, and more. I love being all of them.

Although I'm a poet, *all* writing is my work, from sonnets to this diary and even my e-mails. The question, for me, is how to put more of my best self into this other writing just as I put it into poems – I feel some kind of responsibility towards The Word which I don't always fulfil in my prose. But it has to be fun: the work on computer games has caused me to reflect on the role of play in writing. Like the sun on the flower. But, again, 'play for mortal stakes'.

4 June, London

I wrote a long, technical e-mail yesterday, a project proposal, just after I'd been writing here about about fidelity to the word. And in it, my spelling and grammar went bonkers – as if everything I touch must crumble before my eyes. All of it disintegrating into lovely shards, even the language. I reread Whitman yesterday who consoled me about the thoughts I've been having and trying (badly) to express here. 'Do I contradict myself? Very well, I contradict myself. I am large, I contain multitudes.' And Emerson agreeing: 'A foolish consistency is the hobgoblin of little minds.' And Aldous Huxley, cool, scary: 'Consistency is contrary to nature, contrary to life. The only completely consistent people are the dead.'

4 July, Newcastle

One of my favorite things about e-mails is the headings or 'threads' which emerge as correspondence develops, all these different sorts of communication leaping around together and criss-crossing like dolphins in a school. Poetry threads, learned threads, diary-type threads, sexy threads. Perhaps one can deploy these different genres with less inhibition than when it's all lumped under the one heading, 'correspondence'.

15 July, London

Recorded the first of the *Poetry Proms* last night at the Serpentine. Spent the day at the BBC doing publicity and working on the script with the producers. VERY, VERY, VERY nervous. But the poets performing were fine. I was fine-ish. Self-crit says it was a bit stilted (nerves: too glued to the written page) and that the script was a little flat: poets' biogs and so forth. Better next time.

7 August

At the Proms last week, because going to the Proms is one of the most glorious parts of my residency, I heard Schoenberg's orchestration of Bach's *Prelude and Fugue in E flat major*, 'St Anne'. It's more than an orchestration. He really does kit out the piece in new dungarees and it's not just the effect of full orchestra as opposed to organ. Without changing the notes, he paints them a whole rainbow of different colours – or a kaleidoscope for the ear. Bonkers. The contrapuntal patterns keep moving from instrument to instrument with startling effect. Very strange, very wonderful. You can still hear the organ in there, sometimes quite vividly, but more street organ than the church version.

All this is by way of saying I recognised something in Schoenberg's field of striving which links to my struggles to realise Rilke, or change Rilke, or refigure him, or argue him out of all existence.

SHAPCOTT'S VERSION OF SCHOENBERG'S ORCHESTRATION OF
BACH'S PRELUDE AND FUGUE IN E FLAT MAJOR,
'ST ANNE' (PROM 24)

Where does it come from this passion
for layers? I could eat the lexicon,
breathe whole fugues in German and Latin,
rub notes on my skin to make my pores sing.

Numbers make me tremble in Spring.
I want to counterpoint them till I careen
off the edge of the world disputing
with God himself about the number seven.

31 August

Finished my Rilke book, now called *Tender Taxes*. Feelings? Exhilaration that it's done at
last. But combined with a strange sense of mourning – what will I do/be without it? And
nerves, of course, while I wait for my editor to say what he thinks of it.

choreographer
Shobana Jeyasingh

Born in Madras, Shobana Jeyasingh lives and works in London. She has directed the Shobana Jeyasingh Dance Company since its conception in 1989 and has created a repertoire of original works, collaborating with contemporary composers and commissioning scores from Michael Nyman, Graham Fitkin, Michael Gordon and Django Bates, among others. She has choreographed for theatre and made new dance pieces for television. She received a London Dance and Performance Award in 1988, her third Digital Dance Award in 1992 and the Arts Council Women in the Arts Award in 1993. She has also won two Time Out dance awards and her company was overall winner in the 1993 Prudential awards for the arts.

Over the past ten years Shobana Jeyasingh has created a unique dance language that expresses her British/Indian identity. Using the Indian classical dance form of Bharata Natyam as the starting point for her exploration, her thought-provoking work challenges narrow views of cultural boundaries. She is an eloquent public speaker about her work and its wider context within post-colonialism.

Her diary begins in the autumn of 1999 and traces the development of a new dance piece for her company, called *Surface Tension*, which was to open the following spring.

17 July 1999

Kevin Volans (the composer with whom I'm working this year) drops by. The house is still a bit of a building site. We sit in what will one day be the drawing room and talk about 'surfaces'.

It is something that I have been chasing around in my head since university days when it struck me how difficult it was to extricate the word 'surface' from its post-Reformation residue. It seems to come pre-packed with connotations of superficiality and one-dimensionality – words that have prejudice built into their meaning. The surface, especially a decorative one, is seen as a distraction, a Shelleyan 'painted veil' that has to be torn aside to get at the truth. Given this handicap the only intellectually credible option was for surfaces to be plain and simple – no rhetoric or bombast allowed to cloud their transparency, or riot of colour to deter its functioning as a handmaiden to meaning.

This downgrading of surface struck me particularly, coming as I do from a culture where it is perfectly possible to be serious in shocking pink. It is also a stumbling block to choreographers who make non-narrative dance works and who subversively offer the transient surface and nothing else for inspection, as meaning, as text. A reluctance to engage with the surface renders such dance works inconsequential or liable to be bombarded by the usual 'so what was all that really about?'

Brilliantly enough Kevin has always wanted to write a piece entitled *Surface* so our conversation goes off well.

We talk a bit about classical surfaces where decoration enjoys more respect (Bharata

Natyam dance, Baroque music). 'You can use more Bharata Natyam in this,' says Kevin encouragingly.

Yes, I'll refer to it, but it will be 'in quotation marks'. The dancing surface of a British Asian at the close of the century is a shaken and stirred affair and that will be the thesis of this piece.

All the talk about Baroque music leads us to the harpsichord as a potential instrument. However, we decide that on its own it might be too 'historical'. Kevin suggests a kind of duet between harpsichord and electronic tape. A friend of his, Jurgen Simpson, could be involved in this; Kevin also has a harpsichord player in mind, Carole Cerasi.

Given that young K will be returning from the park soon doing his Tarzan imitations and Kevin's departure home to Dublin is imminent, we have to sort out the major brush-strokes today (our last meeting was mostly about kitchen conversions, Kevin having just masterminded his and I being en route to mine).

This initial dialogue with a composer always signals that Part One of the adventure is at an end. Prior to this I am a free agent, collecting connections from all sorts of places and letting them simmer and free fall. Whatever clarifications emerge as I talk about the concept to the composer also shape it and send it on its way to being something concrete outside my head. Talking it into being is a process that brings relief. It is also tinged with an elusive sense of loss.

1 October

Kevin and Jurgen come with most of the music to the studio where we are doing our pre-rehearsal workshops. I listen to it with my 'dance ears'. It's full of intriguing rhythmical shapes and has an intelligent physicality which instantly appeals to me. I like the way it is

tossed to and fro between live instrument and tape. It is in three sections and the last part (about eight minutes) is a solo for harpsichord which Kevin explains is a bit of unfinished business from our last collaboration in 1990. It isn't complete and Kevin plays me a synthesised 'taster' which sounds quite magical – calm, lyrical and measured.

11 October

Officially this is the first day of rehearsals but I'm already battle-weary. I've spent a harrowing month looking for a replacement dancer for one who had to drop out at the very last minute. The new dancer can only give me one third of the required rehearsal time of eight weeks due to prior commitments. If that isn't nightmarish enough, two of the other dancers are affected by illness and injury. It's like preparing for a long sea voyage in a leaky boat. But 'onwards and upwards!' as my friend Fr Allen would say.

I try out the movement sequence that I've previously sketched on the dancers and, just as I have been for the past eleven years, I'm amazed that the bodily mechanics are there making it work. In some years, the first trials are the ones which are jettisoned quite quickly since they are often the products of a brain that hasn't quite warmed up to the new piece and is still, to an extent, fighting free from the debris of the previous choreography. The first phase in the rehearsal studio, when the raw material for the dance work is created before one has to think of the much more challenging task of composing it, can be exhilarating; especially if the dancers are there with you stimulating the inventing process, solving the problems of movement mechanics with their ingenuity. The goal is to find the most economic movement paths to realise the given idea. One has to communicate the idea to a large extent through movement itself though we end up inventing strange phrases to get at the desired dynamic. The dynamic of this work is going to be quite irregular and jagged.

15 October

We seem to be moving quite quickly, building on our bank of sequences. We set the counts for the first sequence since it has had some time to settle down and I can guess how it will finally look in a couple of weeks' time when I'll be using it in composition.

I try to keep the imposition of counts till the last possible moment since this has the effect of setting it in stone, after which retrieval cannot be contemplated lightly. Bharata Natyam dancers in particular have an innate respect for counts and will do anything to fit the movement into the neat logic of numbers, delivering tidy little packages where all irregularities have been ironed out.

Counts for me are more subjective things, there essentially to assist in the arrival of some sort of consensus between the dancers as to the features of a phrase, like pegs that

hold up a long piece of material to maximum interest rather than maximum security. I definitely want the material to be buffeted about a bit!

19 October

'So what's the piece about, Shobana?'

Ouch!

'The process is that I have a starting point (which may turn out to be the finishing point) but only your bodies and what we can get out of them will determine the end product. It's like one of those games where you join up the dots to see what picture it makes. Except that I don't know as yet what those useful little numbers are that guide you through them. You will gradually tell me that through your muscle and bone at the least expected moments.'

Of course I don't say this.

Fighting the urge to declare an early lunch break I sit them down and we talk about my recent readings of Susan Sontag's work. Her essay 'Against Interpretation' connects with my initial musings on valuing the sensual suface rather than following the Freudian instinct to dig beyond. But even as I speak, I realise the connection is becoming irrelevant to our work. The key loses its fascination once the door is open.

21 October

Make a bit of time after rehearsals to listen to the last section of the music. It is stunning but unlike any of the lurchings to and fro that have been happening dance-wise in the studio. It moves towards such a deep and spiritual sense of resolution (and it is the ending), but I don't know if the dance is moving towards such a closure. Can a rough and tumble tale of whirled-about folk have this perfect, almost fairy-tale, ending? By its scale and authority, it seems to be music that has to be obeyed. So I have tried obeying it. Lots of lithe, dignified, circular movement is the result.

22 October

Spend some time today going through the created movements for the last section. The dancers execute them beautifully – they look almost noble. As I increase the volume of the music (I try to keep it quite soft so that the movement dynamic does not become too quickly influenced by what the dancers hear, especially during initial attempts to introduce one to the other – a bit like brokering a marriage in a way) their nobility becomes even more pronounced. I knew obedience wasn't going to work. They couldn't effect this drastic change of persona in the last seven and a half minutes without running the risk of looking schizophrenic.

27 October

Hearing time's winged chariot doing its damnedest, and sensing that a full ensemble in the studio is going to be a bit of a luxury for this project, I make my first foray into composition: always like the final, no-longer-avoidable trip to the dentist to sort out the nagging tooth, at least for me. Unlike the writer, the composer or the visual artist, the choreographer has to begin the first acts of structuring, with its attendant trial and error and the possible crudeness of a first draft, in the very public arena of the studio. The dancers are the first audience that one has to convince.

I decide to use the earliest of our invented sequences. I want to inject random pauses into it to see how it will affect its flow, shape and dynamic. Strange just how much calculation is needed to achieve a random effect.

Perhaps it's the time and effort that I've recently put into organising a five year old's birthday party but I ask each dancer to punctuate the phrase with their birth dates, so for example a birth date of 2.5.76 would give four pauses of those counts. I was hoping that they would have to negotiate awkward bits of the phrase (which was made of small irregular units). Despite originally running it facing the front, I decide to float them across the stage, in profile and from both sides of the stage at staggered intervals. The first attempt is chaotic since no one knows the pathways of those they are going to meet in the journey across. Once we've resolved that (the watchword being 'safe, but not too safe') they feel more secure but it still does not have the texture that I am looking for. The arrival to and from the pause needs more abruptness and edge. We work on treating the pauses like fast edits in a film. Jiva (Haran) grasps the idea and I can see that his phrase suddenly takes on a much greater strength.

Though today's work is far from finished it is good to know that at least two and a half minutes of the final bit is acquiring some semblance of form.

29 October

Made a solo for Chitra (Srishailan) – suddenly we're in the fast lane! Her five years with the company means we can read each other fluently and accurately. One can have an idea, prod it about at length and see the final result delivered in the shortest possible time. Bliss. I'll probably use the fast, rippled music from section two for her. It goes with the taut, quicksilver way she moves.

I still do not have a clue about the last section.

8 November

Poor Jasmine's (Simhalan) back is giving her problems again. A pity since she's been dancing beautifully this year. I only hope it's not going to be a long-drawn-out affair like last time.

10 November

Jasmine comes back from a visit to the physio. Suspected slipped disc. I can't bear to think about the implications of this for her, for me and for the other dancers.

15 November

A welcome change of studio, to the Jerwood Space. A lovely, big, light, airy studio with café and showers attached, and where our own offices are based. None of the inner-city deprivation (uneven floors, leaking roof, Jurassic toilets) that we had to contend with in our previous place.

This should be a high point of our rehearsal period but it is not. I walk into the studio in the knowledge that it is one of those stiff-upper-lip moments where I know things are visibly crumbling all around but as the resident cheerleader and keeper of faith I have to pretend that having just three workable dancers out of the total six (back injury, knee pain, contractual complications) is all in a day's work.

Spend most of my lunch break discussing the pros and cons of cancelling our première. The practical implications (loss of revenue, negation of signed contract, jeopardising our future with the venue) are all talked up until they acquire a monstrous inevitability. The liturgy of the practical can take on such power that any talk of artistic integrity can seem almost blasphemous.

Come home very dejected to find a fax from my lighting designer, Lucy Carter, outlining her difficulties should the première be cancelled.

23 November

Jasmine's continued absence has meant that the piece is moving forward in snail-like fashion and I'm making all kinds of compositional decisions which I know will not serve it well.

24 November

I go to the opening of the new Opera House at Covent Garden. The balcony scene in *Romeo and Juliet* where music, movement and story come together to make an emotionally charged 'Big Statement' (very seductive and powerful tonight) makes me revisit yet again the last section of *Surface*, music which in its own way is a big statement. I can't match it – or am disinclined to – and yet dance as counterpoint to it will also not work (the music is just too perfect).

Perhaps what I need is a collection of statements, different narratives the edges of which, and the gaps between them, serve as moments of emphasis, as emotional high points.

25 November

I can't believe I'm making new material at this late stage. It's a burden I don't like to put on the dancers when they are coming to grips with the piece as a whole. However it is unavoidable. As movement gains smoothness and economy through practice, one begins to accrue 'redundant' time which makes the texture of the dance flabby. This has happened to the section following the 'classical quartet'.

26 November

Ursula Bombshell (the costume designer) comes in for a final costume fitting which we have to cram into the lunch break. The red looks stunning, brings out the sensuality of the body and gives the dancing surface a real iridescence.

4 December

Spend the entire day in a cold community theatre in the East End with Richard Coldman and Maddy Morris (film director and set designer) shooting the footage for a dance film which will be part of the text of *Surface Tension* (Kevin prefers just *Surface* but I'm hoping to activate the physical science resonances of the title).

There really is no money in the budget to make a dance film, however brief, but I feel an exploration of the dance surface will be incomplete without referencing the body on screen and the way its meaning has been mediated through the artifice of the camera.

As the rest of the world outside enjoys its Saturday while the two dancers repeat a phrase for the umpteenth time I know I've committed myself to a situation (all too common in the arts) relying on unpaid time, unsocial hours, huge favours and goodwill strained to the limit.

17 January 2000

Going to the final production rehearsals in a freezing cold studio in Camden does not feel particularly millennial. The ache in both my legs which developed over the Christmas break is now worse and I have to conduct rehearsals sitting down. The cold does not help and we have to keep most of our outdoor clothing on to keep warm. We hire an emergency heater, only to have it confiscated because it is deemed to be an obstruction to the fire exit. Something on the fiery side would not have gone amiss given the sub-arctic conditions.

The studio is full of hardware (sound system, projector, harpsichord) and assorted personnel (technical manager, sound engineer, tuner, assistant composer, administrator). I have just half a day to sort out numerous cue points between dance, music and film. I get the message that one of the dancers is not going to be there till lunchtime, which means I cannot do many of the things that I jotted down on my list last night. The sheer

frustration of this makes even my aches and pains and the icy conditions take second place.

Carole Cerasi comes in the afternoon and it is wonderful to hear the music played live after weeks of having to work with a synthesised rehearsal tape. For the dancers of course it could be a different story. The living, breathing version could be quite disconcerting after the cosy predictability of the mechanical one. A phrase which seemed to be in the fore-ground (onto which six dancers are hanging for dear life) may suddenly be blown away into obscurity by sounds which our humble studio player has been unable to amplify.

Luckily there are no major setbacks other than some problems synchronising instru-ment to tape. Slightly more worrying is the fact that we seem to have lost a small chunk of the music. We realise that this is because Carole is playing Version A of the score and the tape is playing Version B; this can be sorted.

We spend a good deal of time running the last (tape-less) section. The dance does not use the music metronomically, nor does it reference its dynamic (each now seems to act as a screen through which the other is seen or heard, the movement suspended within the music and vice versa). So bringing them both to a closure at the same time proves tricky. They need to converge on each other's intentions right at the end.

Just when I think the day has exhausted its potential for drama there are tears as a dancer and my office lock horns over some contractual issue.

The close of a draining day. The hardware seems almost rendered invisible by the emotional debris that is now littered round.

22 January
Brighton. The last of our production days at the Gardner Centre. Production days, when choreography, live music, set, lighting and costume all meet each other for the first time in one space, are always harrowing. The whole technical aspect of choreography becomes paramount. It's a most complicated business and yet we have only a couple of days to rehearse it. Insane really. The video inserts are in the right place and I decide to take the dancers off stage when they are shown. Lucy and I are still working on the lighting ideas. We'll have to finalise it at the première. On production days you learn to leave it when the time runs out.

On the way home I ruminate on the fact that, in the transference from studio to designed space, the dance seems to have lost much of its emotional colour. In the short space between now and our première I have to find some time to work on it.

Postscript: September 2000
The pains in my leg which had reached a deafening crescendo in Brighton resolved them-selves into a fairly serious illness. This meant that I never did get the chance to change the

emotional registers of the piece. I missed not only the première but the entire national tour.

I finally caught up with the production just before the company visited Denmark and South Africa. I felt that the vast expanse of the lit cyclorama behind the dancers was working against the emotional and physical intimacy that I wanted. Also, some of the opening structures of the choreography relied too heavily on small, detailed brush-strokes which dissipated the eye's engagement at a crucial and vulnerable stage of the piece's progress. All this reworking had to take in the additional burden of the loss of one dancer due to injury. Perhaps this dance work was always fated to be written on five bodies instead of six!

In Durban, after a veritable safari in search of a harpsichord and many technical nightmares later, I finally made my peace with *Surface Tension*. The dancers were eloquent and Chris (Charles) and Paul (Bull), our technical crew, were masterly.

It was the last date of our tour.

playwright
Shelagh Stephenson

Shelagh Stephenson read Drama at the University of Manchester and began her profes-
sional career as an actress, although she started writing as a child and continued to do so
in her spare time. She eventually made a conscious decision to commit herself entirely to
writing and after years of small successes, especially in radio drama, the breakthrough
came in 1996 when one play, *The Memory of Water*, attracted excellent reviews at
Hampstead Theatre, and another, *Five Kinds of Silence*, for BBC Radio, received three
major awards. The former play reflected with wry humour on a dead mother's emotional
legacy to her children; the latter was an account of life with an abusive man.

Three years later *The Memory of Water* moved from Hampstead, the pioneering new
writing theatre, into the commercial West End where it won the Laurence Olivier Award
for Best Comedy, and has gone on to be a hit wherever it has played all over the world.
In 2000, *Five Kinds of Silence* also transferred to the London stage. The Royal Exchange
Theatre, Manchester, commissioned *An Experiment with an Air Pump*, which won the
Peggy Ramsay Award for new plays in 1997. It was also produced off-Broadway at the

Manhattan Theatre Club in New York. Shelagh Stephenson is now regularly under commission for plays or adaptations for theatre, TV and film.

When she takes up her diary she is involved in the casting of *Ancient Lights*, a new play for Hampstead Theatre, *Five Kinds of Silence* is running at the Lyric Theatre, Hammersmith, and she is simultaneously working on new plays for the National Theatre and the Abbey Theatre, Dublin, the film of *The Memory of Water*, a new film and two television projects.

5 July 2000

Walk the dog in the rain. Get home and immediately consider going to the gym. Or maybe to buy a toner cartridge for the printer. Anything to get out of the house and away from the script. The daily battle: what displacement activity can I dream up now? Trick myself into starting by the usual method – pretending I'm just going to have quick flick through. Consequently con myself into restructuring Act 1 again, following conversation with Hampstead last night. Am forced to admit that Jenny and Ben are right (Jenny Topper, artistic director, and Ben Jancovich, literary manager) about the end of the act. Only delivered the last draft on Friday, and here I am again. Unfortunately, tweaking is like chaos theory: slight restructuring in one area has unexpected consequences elsewhere. This fills me with anxiety and gives me the feeling that the whole play is falling to pieces. It's like trying to catch confetti in a high wind. Bits of the script pasted all over the place, waiting to be slotted back in. Keep coming up with new bits, obsessively removing words, reordering sentences. Wonder if it's possible to keep rewriting a script *forever*. Decide that it probably is.

Am now (7.20 pm) unsettled by a mild remark Ben made last night about a tiny scene I've rewritten, towards the end of the play. Looking at it today, it looks cod. Something

doesn't ring true about it. It didn't quite work before, but it certainly doesn't work now. Or maybe I'm just imagining it. God, I don't know.

Meanwhile, in a parallel mind strand, I'm trying to write a play for the National. A hammock features strongly. Am I going through a Chekhovian phase?

Lie down on the sofa with the dog and a bottle of beer and fret vaguely about the fact that hardly anyone's going to see my play at the Lyric. Not even me.

Out to dinner and whilst having a heated conversation about Cromwell and the English Revolution – about which I know next to nothing – have an idea about restructuring the end of the play. The thought of the complexities involved makes me long to sink into a deep and fathomless sleep immediately.

7 July

Last night, dreamt that my father came to visit me wearing an astrakhan coat with a red bra over his shoulder. I said, 'Daddy, I think that bra's mine,' and he said he found it comforting. Clueless as to what this might mean, but he did look more like my image of the father in my new National play, than my actual father. This is part of the creative process insofar as the characters have started appearing in my dreams. On the other hand, it is a singularly useless phenomenon.

2.45 pm. A bike has just come to collect the Hampstead script because if I don't get it out of the house, I'll keep tinkering with it ad infinitum. I've made some reckless changes and it's now draft number six, I think. A horrible experience with the printer, which kept saying 'can't print'. Anyway, the play's now gone and I'm completely at a loss. Feel as if I've just seen someone off on the train, but now have to sit in the waiting room until someone else arrives. And not only have I no timetable, but I don't even know where

they're coming from. Or indeed who they might be.

Connect my Palm Pilot to the computer to fill the void. The result is spectacular, but I can't see how it will significantly improve my life to have my entire diary and address book on screen. It's not as if I have a complicated date book. I never go anywhere except the study or the sofa.

Had an idea about the National play early this morning, but now can't remember what it was. Decide to go to Hereford next week to see the Mappa Mundi. That being the title of the National play, I ought really to see the original. Don't know what to do with myself. Decide to take the dog for a walk.

12 July

Depressed and in limbo. No idea how to start new play. The fact that it's a year overdue is an added worry. How *does* one write a play? How did I write the other ones? I can't remember. Shall I start at the beginning and plough on until the end? I think that's how I wrote *An Experiment with an Air Pump*. I also recall that that I was stuck on page six for three months.

Spent all of yesterday reading about the history and distribution of woodland in Britain. Fascinating, but not sure what it's got to do with anything. Did discover that the word *forest,* in its original meaning, had nothing to do with woods. It was a place in which deer were kept. In fact some forests had no trees at all.

My other preoccupation: can morris dancing be sexy? Eoin (my partner), who's Irish, thinks this is laughable. But I want dancing in *Mappa Mundi* and I want it to be revelatory. Get rid of the stupid hats and bells round the knees, and have it performed, not by geography teachers with beards, but by a leaping, mixed-race troupe. A joyous, physical manifestation of how our culture can be transformed and reinvigorated by different racial communities. Is this the stupidest idea I've ever had? Maybe I should just write the play, and sort out the practicalities later. Except that writing it is the one thing I can't seem to do at the moment. Look through my research and notes again. Very interesting, but how to make a play out of this? There's a whole section about paper-making, and copper engraving. And another about aerial photography and lost villages and the Barbudans of Leicestershire. Somewhere in my subconscious I know what all this means, but it's not terribly lucid yet. I've changed the names of the central characters five times now ...

Try putting the new toner cartridge in the printer but can't understand the instructions. Should I walk the dog again? She's bored and chewing my chair. Think I might clean the kitchen floor. Or there's a map shop in Notting Hill, maybe I'll go there and look at maps. Or the London Library. Or should I put the duvet over my head and sleep my way out of this?

31 July

Well, something's bubbling up, but I'm not sure what it is. I've taken the plunge and written the first three pages of *Mappa Mundi*. One of the characters sounds like the actor Roger Allam. Because I know Roger's rhythms and intonations so well, this gives me a straw to clutch onto …

Have reached a strange place in the creative process, which may be akin to mental illness. Someone described to me once the manic phase of manic depression: thinking Silk Cut posters were charged with resonance and meaning, and were speaking specifically to you. Everything glitters with relevance, everything is connected and somehow part of a vast and exciting plan, which only *you* understood. That's sort of where I am. A line in a newspaper, a gesture on television, a paragraph somewhere else, and something triggers, a whole set of connections tumbles into place. Everything is connected to *Mappa Mundi*. *Yes*, I think. This character has a profound problem with authenticity. Or whatever. Most of it is useless garbage, and forgotten almost before the thought has coalesced. But some of it strikes gold and I feel jittery and excited, tired and frightened, all at the same time.

Obviously, I'm fantastic fun to live with during this phase; Eoin wakes up in the morning and taps me on the forehead with the words: 'Stop thinking.' He says he can hear the cogs grinding in my head.

2 August

Depressed. Have had some negative comments about the Hampstead play, from a man I've never met, and now probably never will. Instead of thinking he's wrong, I just feel deflated, all the confidence punched out of me. Don't know how to do it, when I look at *Mappa Mundi* it looks like horse shit. Am filled with anxiety and foreboding and wake at 5.00 am worrying about directors, the new film, two television projects, the National, the Abbey, the film of *The Memory of Water*, and the casting of *Ancient Lights*. Like planes stacking up at Heathrow. Will the director's dates work out? What if they don't? Where to next? And so on and so forth. Luckily, the dog doesn't give a damn about any of this as I drag her round the park at 7.30 am.

My new plan is to write a minimum of three pages a day of *Mappa Mundi*, no matter how much rubbish it is. That's 21 pages a week, which means I should finish in say, five weeks max. This reassures me. Even though I know it's absolute nonsense. Some days I write 17 pages (my record) others, 10 lines. Sometimes I just lie on the sofa and fret. But I like to make plans; it's soothing. If I look at the play as a series of small parcels, instead of a huge undertaking, it seems less daunting. Reading this through, anyone would think I don't *like* writing. Maybe it's not a matter of liking. It's more like a nervous tic, or a chronic illness. Also, I'm terribly afraid of failing. A theatre is a very public place to fail …

3 August

OK, today I'm feeling more rational. There's no point trying to force the play. It will come in its own time. It will. It will. But what if it won't? It will because it always does. I will go out and buy some garden furniture and trust my subconscious to do some quiet, unobserved knitting. This three pages a day business is madness. Actually, I'm not feeling rational at all.

4 August

Didn't buy any garden furniture. Bought a load of books instead. The man in Waterstone's said, 'What a weird collection of books.' I mumbled that I was writing a play and he gave me a beady look: 'You're going to try and make a play out of *this*?' Well yes, actually, although admittedly *At Home with the Marquis de Sade* might seem fairly far removed from a piece about maps and the concept of Englishness. On the way home, had a thought that maybe I'm trying to rewrite *King Lear*. Not that that's got anything to do with the Marquis de Sade either. Although in present altered consciousness, everything's got something to do with everything else. Must stop grinding my teeth.

8 August

Well, I'm still in the waiting room, longing for something tangible to arrive. Wouldn't like to say quite how scary this is. One big idea is all I'm lacking, one big encompassing thing. Something structural that I can get excited about. Think I'll go and bang my head off a wall. Looked through the script so far, and it really is just unutterable balls. Have got a director, Ian Brown, for the Hampstead play though, so will now have to spend a lot of time looking through *Spotlight*, that most depressing of books (the directory of all British actors). 'Choose me,' they all seem to be saying. Have spent all morning rewriting a film treatment, so now it's probably time to stagger round the park again with the dog. Maybe something will strike home, who knows.

20 September

My laptop packed in. I sent it away for repair, and after a week of panic, and no computer, bought another one. Which packed up in the London Library the following day. By the time I took it back to the shop I was close to tears. Replaced it with a different, more expensive model, because apparently, they don't make the original one any longer. I only bought it *yesterday*. This diary was trapped on the old laptop until last week, when I got it back. Such are the frustrations of writing in the twenty-first century. Sometimes I want to go back to the quill pen. Actually, that's not true. I love technology. I love the laptop on which I'm writing this. It's as thin as a biscuit.

Most of my creative life is now taken up with casting and re-jigging the Hampstead play. The only person we've cast so far is Dermot Crowley, who's at least 15 years too old for the part but he's so brilliant I'm rewriting it for him.

Am reading some extraordinary books about maps and map-making. And in the middle of it all, am writing a television adaptation of a novel.

27 September

Someone said to me yesterday, 'What's your play for the National about?' and I said, 'Map-making'. They began to talk about how interesting carpets were, and I realised they thought I'd said 'mat-making'. Then I began to think that carpets were indeed very interesting – Islamic design principles, that sort of thing, and one could actually write a play about a carpet. Are some carpets indeed a sort of map? Had to stop the train of thought right here, because this way lies madness.

5 October

Hugo Glendinning phones to say he wants to take some photos for this book. I tell him I can't do Monday morning because I'm taking the dog to the hairdresser's. Otherwise known as displacement activity 117b. He says he'll do before and after shots of the dog. I like the sound of him.

I wonder if Shakespeare had any trouble writing plays? I doubt it. Or Chekhov? Somewhere in my heart I believe that every other playwright, living or dead, is the real thing, and that I'm actually a fraud. And that writing this diary has revealed the awful truth.

Now I've had to move on from the National play again to write the television thing. I'm still reading and worrying though, and having unworkable ideas. Also we've had builders here for the last four weeks and at one stage had no bathroom or toilet. This is possibly why I feel like shooting myself.

10 October

Lindsay Duncan is recording *An Experiment with an Air Pump* for the radio, and listening to her in studio today, had a whole new raft of ideas for *Mappa Mundi*. She's such a wonderful actress that I felt inspired to flesh out a character who had hitherto been lurking rather nebulously in the corner of my mind. To be played, obviously, by Lindsay. Actors don't realise how inspirational they can be to a writer. Especially one as desperate as me.

Still haven't cast the Hampstead play. But it does look as if we've got a rather fine actor, Don McManus, from L.A. to play the American.

11 October

Spend the morning reading a book about morris dancing. Was going to read it in a café but felt too embarrassed to be seen with it. It's terribly interesting, but some of the theories behind it are complete balls. Still, who'd have thought Irish dancing could ever have become sexy? In fact the whole point of it originally, is that it *wasn't* sexy. Mocked in my family as the closest thing to purgatory one could ever experience, and now everyone's at it. Anyway I'm rambling, because this diary has now become number one method of avoiding the play. The television doesn't cause so many problems because I've already done a breakdown, so it's more like joining the dots (if only).

Still casting the Hampstead play. One more part to go. The most annoying thing is actors coming in to meet you for it, telling you they love the play, you offer them the part, and four days later they say they don't really want to do any theatre at the moment. Which is such a huge waste of time for all involved. I'm up to my eyes, Ian Brown's in the middle of directing something else, and we've wasted hours and hours with people who were never really interested in the first place. Or maybe it's just that on a second reading they realise it's a crap play. God, maybe it is.

14 October

Spend the morning casting the last part in *Ancient Lights*. I always want to give the job to everyone. However, I think we may be almost there.

Does playwriting breed paranoia? When I talk to someone on the phone who I know has read *Ancient Lights* (like a producer or someone) and they don't mention it, I spend the rest of the day convinced this is because they hate it and are too embarrassed to mention it.

Oh fuck it, you write what you can.

My New York agent hasn't called for ages, maybe he's gone off me as well.

I'm sorting out the television, still grappling with big structural stuff for the National play. How can I get it to be non-linear in a way which satisfies me and the needs of the piece? Have I started in the wrong place?

Too much going out at the moment, too much socialising, it's exhausting. I never want to go out again. I want to lock the front door and turn the phone off.

16 October

New York agent rings for long, comforting chat. Phew. Keep getting sent television ideas which I don't have time to read properly, but even on a cursory reading are just the pits. Also I have too much on. I can't possibly think about anything else or my brain will explode. Anyway. Have cast the play. Relieved and delighted. That's one less thing to worry about.

The producer of the television piece calls up to say that the network now wants five commercial breaks instead of four, which throws everything out of kilter. Somehow have to try and knit a cliffhanger out of nothing …

Meanwhile, the National play bubbles along in fits and starts. Have just read a lot of stuff about immigration in the fifties. Also Yasmin Alibhai-Brown's *Who Do We Think We Are?* It's all feeding into something. Although I still can't grasp the shape of it. I'm just looking for one simple thing. And now I realise it *will* come to me. I can feel it out there, I can almost touch it. I'm beginning to feel optimistic again.

19 October

Think I've got the flu or something. Feel grim. Get on with the television thing but feel dulled round the edges. Take the dog out to wake myself out of it. In the pouring rain. Completely soaked and covered in mud, both of us. Have to put her in the shower. But come back to the desk feeling a bit more energised. We start rehearsals in just over a week. The television will be delivered soon-ish. And the National play will continue to stalk my dreams until it's finished. There's no getting away from it. There's no getting away from any of it. I just get rid of one monkey and another one jumps on my back.

composer
Errollyn Wallen

Composer, pianist and singer-songwriter Errollyn Wallen was born in Belize but taken to England at the age of two. She read Music at Goldsmiths College and at King's College London, but her early training and passion was in dance and she studied at the Dance Theatre of Harlem. Since 1988 she has undertaken a huge range of commissions from, for example, the Birmingham Contemporary Music Group, the Huddersfield Contemporary Music Festival, the Royal Ballet, all the main television companies and many of Britain's most innovative contemporary music groups. Acclaimed compositions include the *Concerto for Percussion and Orchestra*, for the BBC, *In Our Lifetime*, later choreographed by Christopher Bruce, and her album of songs *Meet Me at Harold Moores*. She has won a number of international awards.

In addition to her activity as a composer, Errollyn Wallen has also played keyboards with jazz and pop bands, such as Eternal, Des'ree and Courtney Pine and Juliet Roberts, and occasionally even with heavy metal bands. She ran her own recording studio in Camden and formed her own group, Ensemble X, whose motto is 'we don't break down

barriers in music … we don't see any', and which has performed in nightclubs, concert halls, cathedrals and living-rooms.

When this diary begins, in January 2000, Errollyn Wallen was resident at King's College, Cambridge, where she was completing her M.Phil. Over the following months she was also working on a commission, *God's Penny*, for the Islington Music Centre, and writing her second symphony, *The World's Weather*. She also presented a BBC television documentary on the composer Samuel Coleridge-Taylor and was regularly invited to perform from her repertoire at a variety of concerts and festivals.

22 January 2000

Greenwich. I'm longing to get down to work on *The World's Weather* but I have to fix my fax machine and do post-officey things. I listen to the fax repairer's warnings of Armageddon: I am to be wary of angels. Shopping in Deptford High Street – a totally different experience to Cambridge Market Square, no yams or plantains *there*. A wisp of a Creole accent reminds me with a sudden pang of Belize. I say a quick prayer for Ernesto, the 11 year old friend I made there at Christmas.

There's always a sense of trepidation before I begin, like last year in Florida when a group of young girls taught me to jump wildly into the bay from the landing stage. It's Saturday. I'd like to reach bar 50 by Monday and I'm at bar 34. The trombones have just made their first entrance …

23 January

I am discovering in minute detail the difference between solitude and loneliness. When work is going well I am absorbed in a 'stream' and feel utterly connected. It is when I am

anxious about it that I feel loneliest. I sometimes feel as if I've been lumbered with an anachronistic gift; compelled to sit alone in a room without sound, at perhaps the busiest, noisiest and most conflicting time in earth's history, and write music for – a symphony orchestra. Yet this is what I must do, I must watch the little black ants creep across the page over minutes, days, weeks, years.

24 January

Cambridge. I show the beginnings of *The World's Weather* to composer Robin Holloway, a Fellow of Caius, and he shows me his 'Finellium Marmalade'. We peer and poke at the oranges bobbing in the steaming pan. He has good and useful things to say about writing for the harp (the piece begins with harp and double basses) and advises me not to question my 'flow', just to be grateful – and to keep going.

25 January

So many practicalities: tapes to send off to a publisher (we're beginning negotiations) a programme of my works to plan for the Chard Festival in May, decisions about which of my songs the Eikanger Brass Band will play (with me singing at the piano) at the Aperitifo Festival in Bergen, also in May. Musical director Ray Farr has asked to arrange them. Meanwhile I've mislaid the notepad with scribbled ideas and texts for *God's Penny* to be performed by the children of Islington Music Centre on 3 April. I haven't written too much of earth-shattering proportions yet.

Having a sound-system with decent radio reception in my room is re-revolutionising my life. Everything I hear gives me countless ideas for pieces. I've lived for years in relative silence.

30 January

Urrrrrrgh. Still can't find the notebook for *God's Penny*; will have to get on without it. Today, for the first time since I began thinking about this piece (last October) I feel the shape of it. Work on it at home in Greenwich, and it flows, words happily presenting themselves with the music. Maybe the Benylin cough mixture *is* working!

31 January

The World's Weather. In the end you just sit down and *do* it. You make it easy for yourself. By doing it. No more torment. Just you and the paper. Blessed relief. Shaping your very own world. Out of mud. Out of imagination. Why question it?

2 February

I love what I do. When I'm doing it I feel out of harm's way.

4 February

In composing I am trying to understand the fundamentals of music and the patterns of motion in sound. I crave essentials.

7 February

When I consider all I have to do, I feel beleaguered. Still, *God's Penny* is finding its own swing. It helps so much to know exactly who I'm writing for.

A visit to the doctor: I don't have a chest infection, so to Boots straight away for more cough medicine, inhalants, lemon, ginger, vapour rub, tissues … Monday: I've got to kick this thing by Thursday's concert.

8 February

I wake up and phone singer/conductor Madeleine Lovell for her singerly advice, then inhale, cancel tomorrow's rowing and – relatively speaking – chill out.

9 February

Still struggling. I realise I've been dragging myself around for some time. Practise for tomorrow. May have to cancel if my voice doesn't return sufficiently. Although the virus is oppressive, I feel grimly determined. It's just past midnight. Helen Tunstall thinks she can play (the harp) in *God's Penny* on 3 April.

10 February

After a day feeling gruesome the gig is *tremendous*. Right up to the sound-check (when my

bass player Tim Harries nervously asks just how much of my voice I am saving) I think I'll have to quit. Keynes Hall in King's is small and there are about 100 Fellows and students in it. The feeling of warmth from them is delicious and intoxicating. Everyone seems to dig the songs from *Meet Me at Harold Moores* and half of them buy CDs afterwards. Man, I love performing when it's this good. The fact is, my voice is barely there and I have to adjust the contours of songs to take account of its frailty, but something magic is happening, electric communication on stage and the enthusiasm of the audience. My heart is full.

11 February
Bask in some glory. Delightful concert in evening at Caius, Jeremy Bines directing and conducting his ensemble from the piano. All Ravel apart from Stravinsky's *Three Japanese Lyrics*. Excellent playing and such wonderful music.

12 February
Go rowing in the afternoon and am feeling shivery by evening. Rally to 'sing' in King's Voices concert in the chapel (Beethoven *Mass in C*) although I haven't had a voice for a month. However, put on red lipstick and Patrick Cox houndstooth shoes and there's a good party afterwards – with marshmallows.

13 February
Very shivery. Little Evie phones to ask if I am coming to Yorkshire. I am lying collapsed on my bed, still with my coat on. Force myself to do the three-hour drive. Crazy, but I love my precious friends Trish, Caroline, Evie and Maya.

14 February
In bed most of the day. Can't even play properly with Evie. Trish and I go to the Grand Theatre, Leeds, to première of *Great Expectations* by Stef for Northern Ballet (Stefano Gianetti, then Artistic Director). I am sitting behind Stef, or so I imagine, and keep slapping him heartily on the back to congratulate him until I realise it's his twin brother Maurizio. Party afterwards. Lovely to see James (Bailey, ballet master) again. Whole evening a fantastic tonic.

15 February
Always feel better in Yorkshire. Able to go with Caroline to collect Evie from the school crouched beneath dark crags. Suddenly a boy runs out ringing the school bell, through the crowd of parents, round the whole circumference of the school, all his force and energy concentrated on ringing *that* bell. Back to Cambridge at around midnight. Find I've

received a Valentine e-mail (ew.gush) from a fan of my album.

17 February

Greenwich. Decide to stay in and hunker down, cosy amid all my clutter, my piano close to hand, river swirling outside. I want *God's Penny* drafted in rough by Monday (21 February) – so I read *Harry Potter and the Philosopher's Stone*. Chard Festival in May is making me composer of the month.

18 February

Mark-Anthony Turnage's opera (*The Silver Tassie*) is inspiring. Reminds me how big things grow from small, as with Stef's ballet. A good night in the theatre is a *good* night. Have a few breakthroughs with *God's Penny*.

Elgar Howarth (composer, conductor, trumpeter and champion of music for brass) calls to say how I wouldn't believe the way *Chrome* will sound with the Eikanger Band in the Bergen festival. Ray Farr has finished arranging my song 'What Shall I Sing?' and I only faxed it to him yesterday afternoon! Finish my Harry Potter book – truly excellent. I'll send a copy to Ernesto.

19 February

I can see the children of the Islington Music Centre in their bright red sweatshirts in my mind's eye as I work. I'm so enjoying writing *God's Penny*. I feel as though I'm unearthing a new London just when I am discovering the delights of living away from it, my home for most of my life.

20 February

I nearly always work at the piano but much of *The World's Weather* has been written away from it. Today I brave trying bits of it out. I feel a shiver of excitement and have the tiniest glimpse of worlds beyond this.

21 February

Back to King's and this pretty town (well, the ivory-towered bit). A wonderful letter from Ernesto: he has sent me his spelling test (he got 98%) and says I am 'very much missed'. Think I'll go with Dad next September.

22 February

Finish the mud song from *God's Penny*. It turns out to be about a rat's eye view. Get the 'poo' word in several times – for the children's sake …

24 February

Conductor Jeremy Bines comes to look at the score of *Hunger* (for 19 instruments). We're going to do it in Emmanuel College next term. Walk around all day with a tea-towel in my coat-sleeve lining, without realising.

25 February

Delicious cross-country drive in the setting sun to St Mary's Church in Kidlington near Oxford to hear the first performance of *Romeo Turn* (for viola, 'cello and double bass). Goes well, although the church is freezing, not ideal for the fingers of the Adderbury Ensemble. A member of the audience tells me she loves my piece and loves my hair. David Hopkins, who commissioned it, seems very pleased. It's being performed again at the Holywell Music Room in Oxford on Sunday.

28 February

Bright, sunny day. Sing lovely Stravinsky *Ave Maria* at Evensong.

29 February

Dangerous pursuits …

1 March

If I call this Mad March and keep saying it to myself I can get through the enormous amount of work I've got. Have started sending off chunks of *God's Penny* to Richard Frostick (director of the Islington Music Centre). Being commissioned, as distinct from happily and gratuitously banging out notes from the piano onto the page, gives me an association with homework. As I've hardly ever done any, there's a dread of being found out. Sometimes I have to remind myself that I'm doing what I love and know. I am dedicating the piece to Ernesto Kerr in Belize and the children of the Islington Music Centre. I know he'd love to be friends with some of them. Deliriously happy to be well again; composing is such a physical activity and I hadn't realised how weak I had become.

3 March

The première of *God's Penny* is in a month. Although the shape and the structure are clear, in music it is detail which makes all the difference between a clearly executed and a scrappy piece. It doesn't matter how good the *idea* is, the details – the housework – bear the task of illuminating it. I'm writing a paper about Michael Tippett and his use of spirituals in *A Child of Our Time*. It is extremely painful delving back into the history of slavery. Did he know what he was taking on? These are more than simple folk ditties – they are

cries and wails of survival. Am also thinking about a ballet with Stef, *Macbeth*. I'd like to try combining electronics with the orchestra. James thinks Stef would go for it.

7 March

Post more music to Richard Frostick. Always a surge of relief and release when that brown envelope slips away into the darkness of the large box in Trinity Street.

14 March

Jeremy Bines now has the instrumental parts for *Hunger*.

16 March

Vic Gatrell, a Fellow of Caius, is finding out what day of the week 3 April 1500, was – so I can find out the chant specific to that day for the opening procession of *God's Penny*. Stephen Cleobury (King's College Music Director) will give me a copy of the original chant to fiddle with.

21 March

That missing notepad with ideas and words for *God's Penny* has finally turned up as I'm in the final throes of it, in a folder of music left in the Porter's Lodge. Please, *please* let it hurry up and finish. It's a far bigger work than I'd anticipated, or indeed than was commissioned. Ideas kept coming so I've kept going. Just when I think I've finished I read about 126 new species of wildflowers found on London bomb-sites after World War II. *Have* to include another song. It will include the audience whispering their names: Ragwort, Gallant Soldiers, Greater Plantain, Penny Cress …

22 March

Finish all the vocal parts. Put songs in order. Photocopy and post off the new bits. Have to finish the harp and percussion parts now.

24 March

The British première of my setting of Ted Hughes's poem 'The Warm and the Cold', for baritone (Peter Savidge) and piano (David Owen Norris), in Abingdon. (The first performance was in New York and coincidentally on the day Hughes died.) Just make concert. Friday evening traffic.

27 March

Spend some hours with harpist Lorette Pope in Christ's seeing what does and doesn't work.

29 March

Meeting at the South Bank in London to discuss an opera commission for Broomhill Opera next year. Start to organise my birthday party at the Oyster Bar in New York.

30 March

Four days to the première of *God's Penny*, two to the first rehearsal I attend. Feeling good but the thousand other things clamouring for my attention are like water closing over my head. Water. I've decided I must live by the sea. I can't go back to noise.

31 March

Speak with Margaret Leng Tan, whom I call the Kinky Dinky Diva of the Toy Piano. She's been performing my *Louis' Loops* at the Beethoven-Haus in Bonn and the Smithsonian in Washington.

1 April

Islington rehearsal. The children are just great, but 'first composer rehearsals' are overwhelming. The impact of hearing music one has spent months beavering over in a new acoustic environment – the real world, the intended space, not my head – is high-octane. I'm immediately made aware of the magnificence, magic and alchemy of music – and of my failures and miscalculations.

3 April

Première of *God's Penny* at St Giles Cripplegate. Only time to perform 15 minutes of the 45, so it is a taster. It goes really, really well. Part of the 500th anniversary celebration of the Cripplegate Foundation which sponsors Islington Music Centre. Amusing sermon by the thespy Bishop of London.

4 April

Send Ernesto the programme with his dedication.

10 April

Birthday in New York. Drinks with American mates at the Oyster Bar beneath Grand Central Station. On to Haveli's in the East Village for dinner. A motley crew of struggling artists and writers.

13 April

From the beauteous Grand Central Station with its blue, fishy ceiling to New Haven and

Wesleyan University for talk and performance, with my friend Zinovy Zinik, the writer in residence. Our discussion on 'Emigration as an Artistic Device' is so-so. We're coming at it in different ways. It is better when I just sing and play. Great to see American experimental composer Alvin Lucier again. I adore his humorous wit and twinkling eyes.

29 April

Cambridge. Have been looking at the score of *Hunger* and listening to a recording. Was too close to it before. Now I can see the things that need improving. Think my inner ear has got sharper. Remembering the circumstances in which the piece was written is painful: it was a year after Rory (Allam, friend, lover and muse) had died and I'd just finished writing my chamber opera *Look! No Hands!* I was exhausted. I think, however, that we can make something of *Hunger* in performance. Hot, hot day; Jeremy and I spend four hours wheeling timps and drums across town. Loads of comments ('Drum 'n' bass, man') and people thrumming their fingertips on the skins.

30 April

Spend morning sorting out more percussion. Borrow a thunder-sheet. That's the last time I casually mark a dot on a page which turns out to break my back.

Haunted by memory – *Hunger* is dedicated to Rory.

1 May

Very good rehearsal tonight. Jeremy is very relaxed and clear with the players. The learning curve of these young musicians has been extraordinarily high. *Hunger* is beginning to sound gutsy.

3 May

Great concert. *Hunger* goes excellently as does Stravinsky's *Dumbarton Oaks*. In the final rehearsal I decide to end *Hunger* with the quiet rumbling of the thunder sheet. Jeremy conducts superbly.

13 May

At around 11.00 on Saturday night go over to King's for a quick burst of piano practice and get locked in – all night. Faulty lock, disco overhead. No one hears me screaming and banging until the next morning when someone comes to practise next door. There is no way out and no window in that room. I am more furious than scared. I sleep in the velvet curtains which I wrench from the walls – and put thoughts of peeing from my mind.

18–22 May

Bergen, Norway. Have fallen in love with this place and its air. Feel impelled to travel as far north as possible through water. No time on this trip. Great to see Elgar Howarth again – big hug. The Eikanger Band are a crack team. I've never heard *Chrome* sound so sleek and powerful. It is performed on three successive days, starting in a huge warehouse on Friday. Singing some of my songs from *Meet Me at Harold Moores* with the band (and Ray Farr's arrangements) makes me feel like a 1940s American star. The concert on Saturday is in the Grieghalle and includes Elgar Howarth's *Ascendit in Coeli*; on Sunday it doesn't rain and *Chrome* has a fine outing in the town square. I video it. A man shouts: 'Hallelujah!'

Back to Cambridge just in time to sing at Evensong.

28 May

Chard Festival in Somerset. Drive there and back from Cambridge in a day. One of my best gigs ever although I am shattered. Relaxed, happy atmosphere on stage, great musicians, everything gels, the audience stamps and cheers. Realise it is the tenth anniversary of my band Ensemble X.

Drive home with Ray Charles and James Brown. Get to Cambridge at 3.30 am in a glow.

8 June

My feet are in the mud; eyes are in the stars.

10 June

Am about halfway through *Tiger* (a piece for organ). This is inspired by thoughts of the poet Veronica Rospigliosi as she lay dying on Christmas Day 1999, gently repeating the words: 'I am thinking about the shape of a tiger.' My first attempt was jotted down on two pages of A4 manuscript paper. Most of that was jettisoned. I kept the opening statement and a couple of ideas which I've sharpened and expanded in this new draft.

Once I've started a piece I feel really tense until I've completed it, and then it's immediately on to the next. Ten weeks to complete *The World's Weather*.

Walking past King's Chapel I feel so glad that *Tiger* is going to receive its first performance there. It encourages me to think big. I like to imagine that the dusty, trumpeting angels on the organ screen will hear it. From small things … Margaret Leng Tan is going to perform *Louis' Loops* (my toy piano piece) in a Wigmore Hall concert with Evelyn Glennie and Emanuel Ax next spring.

Singing in the choir has really strengthened my voice.

16 June

Spend 15 minutes with organist Ben Bayl (King's Senior Organ Scholar) playing through *Tiger*, really just going through sounds and stops. Hope this piece will work, it's quite strange.

17 June

Write the first two bars of *Aries* for unaccompanied chamber choir. Setting of part of a larger poem by W.S. Merwin, 'Runes for a Round Table', given to me at my birthday party in New York.

19 June

Tiger is done, written slowly in small chunks, never more than six hours a day. I am conscious throughout of four briefs: remembering Veronica; thinking about her thinking about 'the shape of a tiger'; meeting Faber's commission for a piece lasting between two and four minutes; and filling King's College Chapel on 24 June.

My feelings when I composed this were dispassionate, as they often are these days. I know myself and am more interested in pushing beyond what I can already do. Ben is a terrific sight reader. He seems to grasp the nature of the piece quickly.

20 June

Mornings can be difficult. A golden moon at night.

21 June

Still need a second violinist for the King's 2000 concert in the Chapel in three days. Sorting, faxing, photocopying, phoning, writing messages. Practising my songs is the easy bit, though there's endless work to be done on interpretation, improvisation and *attitude*.

22 June

Sally Butt's going to play second violin. She knows the CD well so that's excellent news. Ben's girlfriend will pull the organ stops so there is no hiatus in the music. I have changed a few registrations. I've now run the gamut of keyboard extremes, from toy piano to organ.

23 June

Have a go on the Steinway installed in the Chapel. Sounds much clearer than I would have expected in those acoustics.

24 June

Painless photo session in the chapel. Rehearsal of my Second String Quartet and songs,

including *Tiger*. Not a great sound-check. Good concert. I feel more nervous than usual. Very formal audience, though some are reduced to tears. I love King's Chapel and performing my music there is a moving, if awe-inspiring experience. All the music that has gone before …

28 June
Singing with King's Voices in Ely Cathedral. According to fellow singer Rosemary Curtin there's a music theatre piece that I should write based on Etheldreda, one of the founders. Hmmm …

2 July
Turning pages for John Butt, Director of King's Voices, recording Elgar's organ works in the chapel. As night draws in I watch the stained-glass windows slowly fade into dark luminous crystal.

5 July
Administration. I really need to improve my technology skills. Possible recital in Leicester in November. Complete performance of *God's Penny* postponed until the autumn.

8 July
The World's Weather should have a storm raging round a point of calm. Will attempt to maintain a child's eye view.

9 July
I make great headway with *The World's Weather* by talking it through with anthropologist Catherine Bolten. She helps me find a less daunting way in than the title would suggest. The story of a single raindrop will contain the story of the world's weather. Am mesmerised by this idea. Want to get *Aries* out of the way now but it's going slowly. Fiddly and fugal.

3 August
Stopping for dinner with a mixture of curious frustration and mild excitement. Have been working in minute detail on some string figuration for *The World's Weather*. Slow work, and I haven't got as far as I'd like. Will *have* to work more quickly.

6 August
Sunday. I am preparing my score for the day's work, ruling the staves and drawing in the clefs for the instruments: flutes, oboes, clarinets, bassoons, horns, trumpets, trombones,

tuba, harp, percussion and strings. This alone takes hours. Getting through a pencil a day. The bells are ringing in St Edward's Church opposite. A door slams. An overcast day. Good for working. Yesterday was a 'blind' day, barely inching along.

As I'm scoring I can sometimes see imaginary individual musicians – a good sign. The quotation at the head of my score is from E.B. White: 'The glory of everything.' Finally, *The World's Weather* is a celebratory piece. I am thrilled to be alive and to be able to summon up sounds from all sorts of exotic instruments.

16 August

Working well in the bowels of King's, can work through the night. At this stage I lose the power of intelligible speech and must seem distracted, 'away with the fairies'. I am. Catherine has brought me back a little silver bird from Greece to help with inspiration.

17 August

Ah, 99's a lovely number; means I'm nearly halfway through my orchestrating. Writing in the staccatos, staccatissimos, slurs and accents in the woodwind section. Brain's getting weary and I'm feeling queasy. Too many notes? Play the same brass passage over and over to find how to place the accents correctly.

18 August

Trying to retain a sense of enjoyment through this last slog. Writing about the process has helped. I've been building a shell to protect myself at a sensitive time. However, I must be like a warrior as well as a turtle to get through.

Looks like I'll be visiting Belize in September with my father, the paradise where I started *The World's Weather*. Will surprise Ernesto.

Meanwhile, somewhere in my compositional recess lurks an embryo Christmas carol. The digital metronome I bought in New York in the spring is proving very useful in calculating the subdivision of beats.

20 August

Ten days until I have to hand WW in. Must remember to leave room for the horns to breathe. Working on the 'benevolent sea' section.

25 August

The final push and I'm feeling afraid. Thirty more bars to orchestrate. As soon as I finish I have to write a carol and a set of variations for piano. I feel physically ill and have lost my appetite. Don't want to disappoint myself.

Some of yesterday was lost as I had to go to London to record a voice-over for a TV programme on the composer Coleridge-Taylor that I'm presenting. At last I've booked my ticket for Belize. Every day I think about how I need green and quiet to compose well.

The sun is setting and King's is resplendent against the sky and grass. I am feeling much calmer and quietly satisfied that I'm writing the piece I've been dreaming about for years. It's not very long and I'm surprised at how much of it becomes joyous and dance-like after the dark asymmetrical rhythms of nature in the first part. I am enjoying letting my instinct guide me in quite technical considerations.

Gosh. Writing the high lines above the stave for the flute is giving me vertigo.

Party. Walk back through King's in my 'Wizard of Oz' shoes which hurt a bit, chatting all the while with Catherine whose wisdom I'm acknowledging in the dedication of *The World's Weather*. Do another hour's work and crack a contrapuntal puzzle in *Aries*. Composing just before I go to sleep gives me a sense of well-being and often, in this wound-down state, ideas flow more easily.

27 August

Emblazoned on my mind in gigantic theatre lights is the word FINISH. I must. There's a palpable fear in my belly and I wake up in the middle of the night sweating music. Seven or eight bars to go. Up against the deadline but I'll do it. *The World's Weather* was started nine months ago, put to one side for months and finally sprinted through in the last six weeks. Must remember to go back and put some *divisi* markings in the strings.

Later. Bar 218, two to go. Was feeling forlorn, as I sometimes do when I'm coming to the end of a big piece. Then I get a 'hit' as I come up with a new idea. This must be what is meant by a 'gift'; the brainwave felt genuinely bestowed. *The World's Weather* is about a new kind of spring.

28 August

Stride across Silver Street Bridge and deliver the last fragments to Martin Iddon, my copyist. Trying to keep calm and not drink too much coffee. I have to accept that every time I look at it there are improvements and changes to be made. That the finishing process is itself without end.

30 August

Binders. West Road. Granta pub. Sleep.

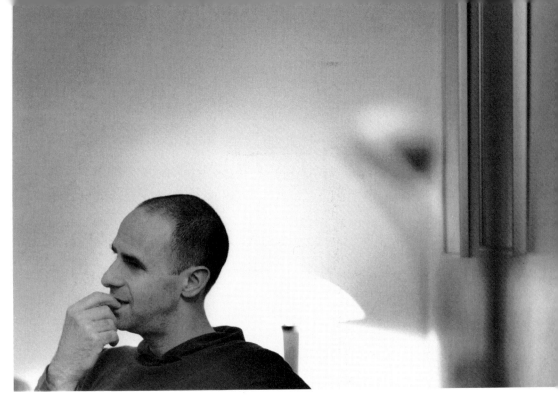

theatre director Tim Supple

Tim Supple was educated at the University of Cambridge and began his professional career in regional theatre, winning a Thames Regional Theatre Young Director's Residency at York Theatre Royal. He was Associate Director at Leicester Haymarket Theatre and directed a number of new plays for the Royal National Theatre's Education Department. He made his name as Artistic Director of the Young Vic, London, where he developed a distinctive ensemble style, producing both classic theatre texts and new plays which he devised from other genres, plays such as *Grimm Tales, Billy Budd* and *Tales from Ovid* (based on Ted Hughes's translation).

In the spring of 2000, *Ovid* was in the repertoire of the Royal Shakespeare Company and his production of *The Villains' Opera* opened at the National. He was leaving the Young Vic and embarking on a freelance career for the first time since 1992.

The diary begins with Tim Supple's arrival in Berlin – with his wife, the designer Melly Still, and their two children – where he was to direct a production of *Much Ado About Nothing* at the Maxim Gorky Theatre. While rehearsing *Much Ado*, he was also preparing to

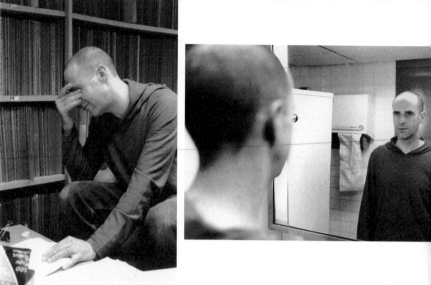

direct *Romeo and Juliet* for the National and his successful RSC production of Lee Hall's new version of *The Servant of Two Masters* was due to reopen in Bromley.

16 April 2000

Diaries destroy what I love about theatre, that every moment of it – preparation, rehearsal and performance – evaporates. It survives only in the memory. As time moves on a photograph, a review, even a film tells you less and less about an actual performance. And the joyous freedom of theatre lies in keeping one's feelings calm and private. To record my experience as it happens is anathema. Nevertheless, I will attempt a diary, underwritten by the security of knowing I may never 'hand it in'.

Tomorrow I start rehearsing *Viel Lärm um Nichts* (*Much Ado About Nothing*) in German with a German company. Less than a week ago I opened my first show in the Olivier to an excited house and a crop of dreadful reviews.

An exciting moment to start my first diary.

17 April

The obligatory terrible night's sleep before the first day's rehearsal was this time plagued by thoughts of never working again in London and ending up with no money as the year turns. For eight years I have had a constant wage, and a continuous world. I was always attached, at home, working towards a sense of what was good for *that* space – even when I worked elsewhere I carried with me an identity. Now I am simply myself.

So this morning I drive to work in Berlin, through the elegant boulevards and cobbled roads of West Berlin, into the massive developments and intersections of Mitte and Alexanderplatz and suddenly, shockingly into the East. The roads even wider, the tram

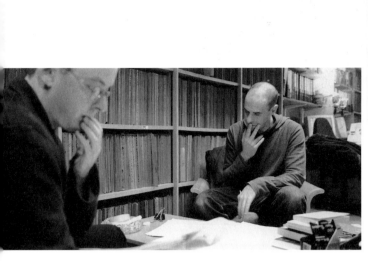

lines down the middle and the buildings no longer elegant but modern and stark. Not unpleasant but bare.

This is where we are rehearsing. Outside, the building is covered in graffiti; inside, light airy rooms for eating and resting give way to inexplicably dark and airless rehearsal rooms. Despite the fact that I like to start with an open room, the mock-up of the set is already there. The actors sit around one big table in the eating area. I enjoy the fact that they ignore me when I come in – but when I go round and shake hands each greeting is friendly and respectful.

18 April

They play with relaxed ease – too much so. Today we worked mostly on detail – focus, registration of what is actually being said. The older East German actors are the naughty boys. They snigger and chat in corners but with good humour and they are easily re-diverted. They seem unused to being present without doing.

There is considerable intelligence in the room but curiosity from only a few. I sense they are not used to discovering, probing together and being asked to contribute. With three dramaturgs present, with their own views at the ready, I sense the culture is one of decision and authority from the director/designers.

I wonder if I am offending Oliver (the senior dramaturg) and his team by not inviting their contribution – today they were much quieter but seemed relaxed. A room without chairs and tables is hard for all these people.

19 April

Olive's birthday. Presents and a special breakfast. Then a tea party.

Yesterday I saw an older actor, who plays a relatively small part, sitting outside in his big car – these actors have jobs for life and are properly paid. They have the dignity of a real job. Quite right too. The only downside is that some become lazy; they can cruise through a scene without curiosity, becoming embarrassed whenever the work becomes real. However, most of the actors here are exceptional and alive with experiment, surprise and real energy.

20 April

A great day out in the East German zoo. A beautiful, grand park with rare, surprising, open places for animals. Mostly a joy except for the severe, small pens for the big cats which leave us queasy.

Tonight we all dress up and go to a true German eatery. 'The best chicken in Berlin' served in half-chicken portions with bread and potato salad with sauerkraut. Benches, long tables and a courtyard in a fine part of Kreuzberg. Perfect.

The Villains' Opera already seems so far away, so long ago. What a brilliant way to escape reviews: leave. It will be the same here. 8 June: open. 9 June: drive home. It's not the answer but it makes a change. Anything that gets me away from the terrible conflict of either an inflated or a bruised ego is good. Please God let me develop the ability and the good fortune to escape truly as I have done now through simple distance.

We are so lucky to be here. The play is superb, the actors very gifted, the design delicious and the atmosphere strong and focused.

Andrea, our assistant, tells me the actors are used to sitting down on the first day and being given the concept for their character and for the production. However, she assures me they have much enjoyed our more open, groping week.

Oliver also says the work was very good and, much to his surprise, the actors are all very engaged. It must be nerve-racking for him. He made this match – the German actors and technical staff with this English team. We had better be worth the bother.

24 April

Four days off for Easter, plenty of time with the children: mostly good, sometimes beautiful. We visit Katya, our former au pair in London who has returned to her native Berlin. Sunday in her garden with sparkling wine, kissing couples and a brunch feast.

Katya's father was born in Berlin in 1945. What a world he has lived in. A city destroyed; the hunger of 1948; gradual reconstruction; the wall in 1961; the cold war and then reunification. And what a city! A short drive takes us to Wannsee. A beach, a bay, and swimming, football, ice creams and chips. Across the glistening water a mansion sits, and there, 60-odd years ago, men planned the final solution.

Today we go to another beautiful, smaller lake in the middle of a delightful forest. On the edge, a grass bank covered in naked Germans. A feeling of freedom.

This afternoon we went to Oliver's. Another table in another garden, long conversations, copious coffee.

I love Berlin.

28 April

At last I grab ten minutes for this diary – which I am actually enjoying. Berlin remains beautiful and hot. The drama in our lives is that Frau Betz (the child-minder) failed to turn up on Tuesday and we have heard nothing of her since. Did she scarper with the first week's cash? Is she lying dead somewhere? We have swiftly replaced her with a nice, quiet young woman from the former East Germany.

I am enjoying rehearsals very much. The actors come well prepared – they have learned their text but it is not fixed. They come with ideas but are not precious. They expect to work hard, for long hours and to have to wait. Rehearsals are quiet and concentrated – they are full of people (two assistants, two or three dramaturgs, a prompter) but I do not find this distracting. No stage management so no obsession with time. We have breaks when it seems right.

3 May

Now I feel somewhat exhausted and disheartened. The play is hard. Too few of the actors seem truly to understand how to play it. I feel under-prepared or uninspired. The language exhausts me and seems to double the time it takes to work. The days are too hot and we have had too many days off.

But this is the way. Tomorrow I will feel differently, I have no doubt.

On the day of my last entry a mild virus came over me – upset stomach and lethargy. This hit the work in the afternoon. We ran aground in Act II Scene 1. Crudely, the men are better than the women at present. Benedict is excellent. The day started well but we had to sit down thoughtfully and calmly with the big scene.

That night, Friday, a lovely meal was ruined by my nauseous insides and the kids had a similar lingering malaise. Bobs (designer Robert Innes Hopkins) arrived late for a weekend of work on the National's *Romeo and Juliet*. So, late night number one.

Saturday morning: a stroll down Bergmannstrasse, a coffee with the kids in the Atlantic Café and then a good five and a half hour working session. Bobs has found a clever, striking and elegant solution to the space and the play. Its elegance needs to be disturbed and its workings need to be tested. But the play could find life.

Sunday sees us finish the work on *Romeo*. And then to the beach for just an hour of

sunshine before a wonderful summer storm. The locals see this coming, and by the time we go to leave the car parks are at a standstill, so we are stranded on a hotel terrace, with tea, cake, beer, schnapps and so on. We pretend we are optimistic Brits holding on in 1934, desperately believing Hitler is not as bad as all that. We watch the storm come and go across the bay and smell the damp warmth as the flies swarm to share our shelter. Great.

5 May

The days get hotter, the sky gets bluer. Yesterday was the reward for my angst and sleepless sense of inability. A good decisive day. The play is giddy, heady. The actors need an inner devil, a fire of fear and loneliness. But they must play with abandon, impulsively – finding themselves totally present in each peak and trough of the experience of life. They are always laughing, always serious, never one or the other for too long.

7 May

This Sunday is my only full day off for two weeks and we are at our favourite place – the Naked Lake. It is beautiful to be with the kids although I continually feel I am too hard on Felix and, ironically try to compensate by spending time with him and so never really play with Olive.

10 May

Olive is very sick. Her cough is now a frightening series of attacks – you'd think she was dying as she goes beyond breath, gulping and barking her way through nosebleed and mucus. The nights are very disturbed. Melly is, as ever, a model of attention and calm concentration. I get upset when she gets upset. It was she who sat by Olive last night but that did not give me much rest as even with the door shut the vicious cough drove through the wall like a nail.

Of course guilt is poking its nose in. Did the stress of change, the unsettling experience of coming here and having different minders, weaken her immunity? The drive to work is unavoidably selfish and will always have consequences.

Felix, poor boy, is coping well. He misses London and sometimes finds it hard, naturally, to remain positive.

11 May

A brighter day in every way. Olive's cough is on the turn. Sleepless nights and dazed days put us both in mind of life with a young baby. It is time to have that focus, to bring another life into the family, to put work back into perspective, to stop smoking and drink less. We must begin now and not think of the timing.

I was so exhausted yesterday I'm sure I strained in compensation at work. Nevertheless, two good days so far this week. The beginning of the week was tough and detailed for the women but we certainly achieved a clarity and definition and suggested a reality. The real progress was made with Dogberry and Verges. True lives are emerging and it seems as if we are discarding preconceived layers of comic mist and glimpsing a beautiful idiosyncrasy.

And yesterday Act IV Scene 1, the wedding. Focused, exciting, detailed work. These big verse scenes need time and patience. Experiment is needed in each moment; different approaches suiting different stages of the scene. But these actors are skilled and open and so one feels the possibilities open up before one.

After the clarity and detail, of course comes the great challenge of belief and reality. In the wedding scene the characters share certain beliefs, in different shades depending on their circumstance, and they carry thoughts about each other and their situation that shift endlessly in the moving waters of the scene. To keep track of this and to make deep contact with the words spoken and heard is the task.

13 May
Strange to be in London on a tube train. Strange to be at the National working on *Romeo*, close to *The Villains' Opera*. I feel affectionate but distant, like an acquaintance I enjoyed some very good times with but who never entered my heart. *Romeo* I am excited about. Shakespeare is so good, the characters so finely, vividly drawn, the situations etched from the most basic and shared experiences. The last few days in Berlin, *Much Ado* has shown its beauty and brilliance to me. I have fallen in love with the characters in more depth than with those of any other Shakespeare I have done. And those actors. On Friday morning watching Harald and Jackie, working with such reality, I did for a moment think I want to work with German actors for the rest of my life! Exaggerated and not true, but I know what I meant.

When I first arrived in London last night I thought it was so dirty compared to Berlin. But today the river. So handsome and splendid. And I think how lucky I am. I love both places.

15 May
Back in the plane and oh so strange. I do not like this endless sense of rushed decisions and unsatisfactory contact with people in the briefest of meetings and auditions. At least in rehearsal I can settle and be – here, now.

Villains feels other than myself. Funny enough, gutsy enough, rough and crude. But also flippant, un-artful and at times camp. My life has been peppered by work that is not

me. *Billy Liar*, *Blood Wedding*, *Omma*, *Slab Boys*, *Coriolanus*. Sometimes through bad choice of text, sometimes failed work with actors, sometimes bad choice of actors, sometimes misdirection.

With *Villains* it is also a result of unresolved collaboration. A good idea of Trevor's (Trevor Nunn, Artistic Director of the National Theatre) and the hurried attempt of Nick Dear (writer), Stephen Warbeck (composer) and myself to find a creative fusion. If we had taken Gay's original *Beggar's Opera* to experiment, to workshop, who knows what we might have created? That's the way from now. Experiment first. Assume nothing.

Back in Berlin. Joy. But pleasures and excitement still await me in London. A good cast? I think so, I need more time. And a pleasure to meet Connal Morrison (who is to direct the same actors in *Peer Gynt*). A wild man, a big man. A full-on energy. Rough, and a powerful spirit.

19 May

Now: it's harder.

Firstly I'm very tired, from broken nights and early school mornings. And the trip to London. Secondly, probably because of this, the language becomes a veil that can only be lifted by the cleverest of actors, like Harald.

21 May

An emotional weekend, mostly because of children and exhaustion. A trip to packed, chanting Olympic stadium on Saturday afternoon and then a tearful watching of *A Little Princess* with the family.

Today was more even. Tonight I was left stunned by Renoir's *The Rules of the Game*.

23 May

And so it comes, inevitably: nerves. Yesterday Harald floundered in his garden scene. Monday morning, all four dramaturgs and the rest present, and an actor lost, talking to the audience when he finds it hard to do so. The garden scenes are hellishly difficult. They read as pastoral frippery; one knows there is another, more painful, surprising and truthful possibility, but how to find it?

Harald is confused. Not settled, not clear. And of course my 'way' often causes anxiety at this stage. Still asking them to change and discover the next possibility with only two weeks to go! Anyway by the end of the day he is clearer and calmer.

Today Dogberry and Verges are more at ease and ready to rip it up and start again.

But then the women hit me with the biggest bollocks about the translation, begging me to consider another gimmicky, modish almost-adaptation. I try not to despair. And

then I realise that this is, as always, symptomatic: insecurity within has been reinvented as an external problem.

27 May

On Thursday we went on stage – two weeks before the opening. And I immediately felt the advantages of the German way. To spend so much time on stage – interspersed with returns to the rehearsal room – allows one to begin gradually to expand one's thinking, and the actors' playing, to fill all the corners and possibilities of the stage.

On the other hand the stage makes people more tense, more impatient, less easily experimental. As if now we're here we must know what we're doing.

29 May

Why, whenever we reach this period in a production does life seem to fall apart? I stare at the decaying skin of my left thumb and index finger. Now it seems infected and it cries out for urgent attention I cannot give it. Our bank account is well overdrawn with God-knows-what disastrous effects. Our mobile phones have been blocked. Our kids are struggling and pushing the boundaries. So much so, that the latest babysitter says she wants to stop after Friday.

But when we are together, like yesterday – a beautiful, cloudy trip to Potsdam consisting of a long, playful lunch and very long walk around the astonishing, arrogant grandeur of the King's gardens – it is lovely. And we had a run-though on Saturday which was good. A very promising sketch which needs filling. But the play emerged in quiet strength.

In the middle of Saturday night I hear a faint whisper, a new voice deep in me, which says: 'You can't go on like this'. Meaning – you can't work so hard, so much. One day, something in your life will really suffer.

1 June

Christ's Ascension and yet another holiday. We're midway through the technical period and the gulf now seems far deeper than language. How you work on stage, work with dramaturgs, organise technical work, look at a play, prepare for a first night – all this is different and takes twice as long. Added to this is the usual tension – the waiting as Adrian Lee (composer), Melly and I weave it all together.

Without any recognisable stage management system it all feels perilously haphazard – altogether too much panic and shouting. Oliver's presence alone is agitating. We end up partly arguing and partly forcefully discussing priorities; the actors' needs, the nature of the show, the design and the play. It is exhausting but also interesting to be challenged and provoked.

3 June

Another beautiful blue day and my last weekend in Berlin. The end of our time here. So many mixed feelings: tension and exhaustion from the build-up to opening, with the added intensity of no previews – the first performance is the opening night. Some sadness, some relief. There is so much I love about the city and so much I have not done or experienced here. But I have got to 'know', as you only do when you are working, a particular group of Berliners. And how strange to be leaving them the day after opening. Again, some sadness and some relief.

But is this really a good way to work? Can I really commit to them and they to me and us all to the project when I am running off the next day? Might I care a bit less because I am not going to be around?

6 June

This morning I think I am past it. One run-through later I can only pray to God. Two runs later, I can see the light. The play has crept into focus. Tentatively and in part.

8 June

The afternoon of the première. So tired I feel my judgement is at its limit. They are tense and tired. My vision is impaired by my sense that Berlin wants more *attitude*, more interpretation. Will we be booed tonight?

Later – 6.30 pm – waiting for Melly to arrive with my clothes. Still more deeply unsure of myself. Busily creating a more abstract, more stripped production in my head. Would I be having these thoughts in London? Different versions of the same perhaps.

4 July

Oh dear, dear diary. Its so long, a month nearly – can it be? – and I have so longed for you. Now, finally, we are alone and it is such a low moment in my heart. Again. There have been high moments since the last entry, many high moments, but the swings are frequent and considerable.

How did it go at the première? I don't know. I haven't had time to phone and ask. I guess the reviews were not good. This seemed destined and confirmed by the atmosphere.

5 July

Last night's despair subsided today after some sleep, the gym, some work and the relief of getting some of my anxiety off my chest to Jenny McIntosh (Genista McIntosh, Executive Director of the National Theatre), then realising that the rehearsal situation is not quite as bad as I'd feared.

Berlin already seems another time and place entirely. What was it, now, for me?

Rehearsals were good. Indeed if we'd gone on for a month or two working with the actors I think the experience would have remained golden. The work on stage was an increasing nightmare. We worked as if we were not in the same room. They became more and more unsure. The technical culture was alien. The interference of the dramaturg was disabling. By the end my desire to work abroad was all but extinguished.

12 July

I find it hard to believe I'm back in rehearsal for *Romeo and Juliet*. Locked in a work tunnel until *Servant* opens in Bromley at the end of September! Despite this, I feel surprisingly alive and alert. Indeed I am greedy for this play now, greedy to push myself for new sensations in rehearsals. This is the time not to do what I know but to be alert, listen, and watch and respond.

But there is intolerable strain in our personal lives.

24 July

Saturday marked a clear ending – I left the Young Vic officially. The last night of *Ovid* and a party to mark the end.

27 July

Sitting by the Thames on a most beautiful summer day. Boats, water, women. Am I jaded? As usual it's time that irks me most. It's the same here and in Germany – there is not the time to create theatre like art. To sit and think and watch and wait, to let something arrive. It's all hurried, snatched doing. Brief, groping guesses. Last night I rehearsed alone with Chiwi and Charlotte (Chiwetel Ejiofor and Charlotte Randle, playing Romeo and Juliet). No stage managers, no assistant, no watchers. *That* was a rehearsal. Probing, incisive work. Moving with the tide of thought, natural, simple work that produces natural, simple action. If it cannot be like that throughout I fear for the show. And I fear for my patience, my appetite. Yes, I am at that 'Should I be doing this?' moment.

15 August

I have a spot on the end of my nose that has hung around longer than any blemish in living memory. Is this some kind of punishment? Certainly it seems destined to coexist with *Romeo and Juliet*. It will presumably fade when I come to the end of rehearsals. I am loath to record even the vaguest assessment of them. Shakespeare is always surprising – at any moment you can be confronted with your failure. In the rehearsal run, during the technical, at the dress rehearsal, at the first preview. And his plays are, in themselves, deceptions.

Time to wrap it up. There are so many unfinished entries and missed episodes that I at least want to sum up my present thoughts.

Berlin seems to me to be a hothouse. It is highly self-conscious, pedantic and agenda-bound. Intellectually restless but not truly curious. At its best iconoclastic and avant-garde but – in its desperation to be so – often empty and puerile. It is resolutely suspicious of anything gentle, delicate, beautiful, of love – it searches always to highlight the harsh, ugly, brutal. Its amateurish practices in stage management and technical work can be refreshing but were ultimately infuriating. The atmosphere driving the technical period was impatient, uncreatively temperamental and more than a little racist as regards Kemal (a Turkish-German musician). The ensemble was OK but not as good as you can assemble from the more open British market. The fixed nature of the ensemble produced a daily ease of work but I missed the excitement of a new journey. Shared traditions produced some interesting qualities on stage but the older actors especially were fixed and dull. Even some of the younger ones were already stiff. Only one actor was truly alive to the moment and could fully combine the Berlin passion for extremity, ideas and outer meanings with my insistence on reality and contact with one's thoughts, words and the person you are talking to. I should have insisted on my preference, *Titus Andronicus* – this and ignoring my doubts about *The Villains' Opera* are my greatest lessons from the year. Insist on what you want and you will get what you want.

Then the language – first interesting, then debilitating. So: don't romanticise German theatre. Well funded, well respected, adventurous in conception, thoughtful of the purposes of theatre … but also bureaucratic, critic-conscious, self-deceiving, shallow. Just like ours – visionary in some respects, narrow-minded in others.

Ovid rehearsals were a joy simply by virtue of not being the Berlin experience! Yoga every day in a light sunny room; three members of stage management; a show we knew; a language we all shared – in every sense. There were moments on the last night when I observed the essence of the delight I experienced in the Young Vic. All the neurosis and self-doubt, the wasted thoughts about what critics or peers or audiences or I *think* of the work, fade away when one simply dwells in the joy of the shared moment. At the heart of the Young Vic lies my true heart. In *Grimms*, *The Comedy of Errors* and *Ovid* lies my true self, I think. But one's self keeps moving; mine must seek *it*self elsewhere. It confirmed my feeling that it was time to move on.

So where am I now? Without the anxiety of boards and budgets and planning and staff and responsibilities. Also without control over how I work and who with and what I do. I need to work to live. But I feel, foolishly perhaps, that I will be all right. That events or God will provide. It is 20 years since I decided that I must direct. A third or a quarter of

my life (at most). So now I must know if it is the path for the next 20 years or if it is time to look for another.

In my most negative moments I feel this cannot be the rest of my life. Directing, I think in those moments, is such a diluted, compromised task. So many, many hurdles and filters: producers or artistic directors, designers, actors, production and administrative staff. If I really have stories worth telling, art worth showing, maybe I should write novels? It's the only pure art I could even try. But would I have any skill? I look at a picture of Olive's on our wall: the whole family drawn in stick-like figures, scarecrows floating in mid-air like spirits. But each of us is somehow so simply accurate. Can I ever improve on that? Is art as a representation of life a futile pursuit? An avoidance of life itself? And if it does have a reason, what is it? How far am I from it?

At other times I feel the excitement of a production as I am now experiencing it – 34 actors, six musicians, a designer and crew waiting. A familiar story in a great written form, waiting for us to fill its worn but magical clothing. I see life made vivid for us to marvel at, object to, applaud. And in the harsh glare of clarity we understand our own lives as shaped by others and ourselves. All the messy, compromised mist of theatre takes wondrous form.

And lastly and most important, Melly is sick every day but I am glad. Because what is making her sick is the miraculous, selfish, unavoidable process of a life growing inside her. And in the short misery it causes her – which I fail to see the justice of in any way – and in the years of renewed tiredness and toil that await, I can only find joy, optimism and vigour for life. To be lived. To be enjoyed.

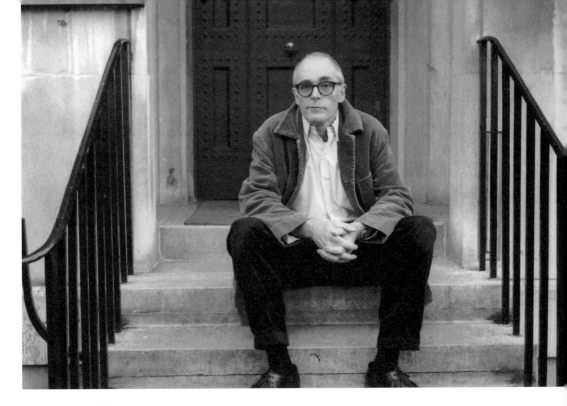

sculptor
Richard Wentworth

Though born in Samoa, Richard Wentworth is a Londoner through and through and the city nourishes his art, photography, sculpture and 'interferences' (his preferred term for 'installations'). He studied at Hornsey College of Art and the Royal College of Art before working briefly with Henry Moore. He taught at Goldsmiths College London where he had a significant influence on many young British artists.

In his own art he creates disarmingly poetic sculptures from everyday objects, juxtaposing them with a combination of wit and affection to draw attention to the arbitrariness of our surroundings in the civilised city. His manipulated buckets and chairs appear as distinctively different from the work of his British peers. He has exhibited his work in many of the world's leading galleries and is also often commissioned to make 'interferences' in response to buildings and cityscapes, old and new. He is increasingly consulted by architects and planners for his original insights into the way we unthinkingly use our built environments. *Making Do and Getting By* is an ongoing series of photographs (20,000 so far), which record the way we use things for other than their original purpose.

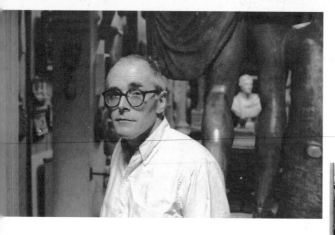

This is a diary unlike any of the others in the book, a refinement of what passed through Richard Wentworth's mind in a single working day. It records a rare (he insists that it will be unique) foray into curating an exhibition, 'Thinking Aloud', which brought together in a conventional gallery an electic array of artworks (none his own) and non-artworks, many of them first drafts, sketches or prototypes from the fields of engineering, architecture and design. Commissioned by the Hayward Gallery as a National Touring Exhibition for the Arts Council, it had already visited Kettle's Yard, Cambridge, and the Cornerhouse, Manchester, before its arrival at Camden Arts Centre where it was still undergoing transformation.

Richard Wentworth had also planned a meeting with a Mexican curator and was working on a group exhibition of installations in response to the remarkable collection of antiquities at the Sir John Soane Museum.

10 March 1999

5.55 am

Typical early waking, nervous as hell, the usual torment of mislaid paperwork, which box is it in? They all look the same. It all looks the same. Reverie of watching the first planes lining up over the city on their last 15 miles to Heathrow. Near enough to see, too far to identify, idle speculation about all that diversity converging on the M4, 45 seconds apart. I hear my friend George saying: 'It shouldn't be called a near-miss. It should be near-hit.'

Realities of the day set up the real nervousness, one of those spaghetti junctions of contradictory arrangements, everything to do with exhibiting, nothing to do with making art, the stuff that can never be told in art school.

9.35 am

Standing on the platform of the North London Line rehearsing the day – Jenni at Camden, Patricia from Mexico, Hans-Ulrich from Outer Space (Switzerland in fact). The threatening grimness of the line and its 'service' is worthy of a seminar with Eric Hobsbawm. It could be a great tourist narrative, instead of a scummy, low-rent, commuting drain. Arcing from Kew to the docks (and built to service them) it parallels London's first bypass (Euston Road) and the later arc of the Regent's Canal. It tells so much about London, worth 100 days of queuing at Tussaud's. In the train, travelling north and west via Camden and the tunnel under Hampstead, the windows are so filthy there are no views.

My favourite London contradiction is that the view across King's Cross to the City is on the same latitude as Primrose Hill. The Hill shows all the pleasures of pre-Victorian prosperity, whereas only a mile to the east the view across King's Cross shows London as a working place – cement works, car pounds, maintenance depots, abandoned gas works, derelict canal basins and the Siamese-twin sheds of King's Cross and St Pancras stations.

10.10 am

Finchley Road and Frognal station: I've come to discuss the hanging plans for 'Thinking Aloud' with Camden Arts Centre Director Jenni Lomax and her team. Ex-art student and ex-Whitechapel Gallery during the time of Nick Serota (now Tate Director) she knows how to bang in a nail and paint a wall. She actually likes artists and her reputation for an intelligent and sensitive programme in the near-derelict 100 year old library which is Camden Arts Centre commands enormous respect. She's almost a missionary in the Methodist

tradition, but her Rochdale warmth injects just enough madness into the proceedings.

All sorts of cross-currents wash around 'Thinking Aloud'. The Hayward occasionally invites artists to make exhibitions which tour under the aegis of National Touring Exhibitions. 'Thinking Aloud' is my attempt to make an exhibition which contains non sequiturs the way walking down the street does. I know enough art history to sense which rules I might be breaking, but not enough, evidently, to anticipate pockets of conservative indignation from professionally trained curators and artists. The groundswell of pleasure (and attendance figures) overwhelms the grumble zone, but it's fascinating to watch hackles rise so ungenerously, nonetheless. I am now an amateur authority on the rules and regulations surrounding artwork loans. There is a ritual dance with the big museums and, without the institutional power of the Hayward and its exhibition organiser Roger Malbert's imagination and diplomacy, nothing would ever wriggle free of the various gatekeepers. I have done a lot of tongue-biting, but we have wonderful things from the V&A (Paxton's first sketch for the Great Exhibition of 1851, which I used to trump the Dome), Manchester Museum, Birmingham, the Stedelijk in Amsterdam, and a mountain of intelligent support from the War Museum. Private lenders seem so much more relaxed. Richard Hamilton hand-delivered Duchamp's signature, incredible generosity from Linda Karshan and a beautiful small Guston joining the show at Camden from Gus Danowski (who is named after Guston). Artists seem to like the show so much they'd almost leave work at the door to be included.

As the process of making the exhibition has unfolded I have become more and more confused by why the inclusion of some things works while others turn out to be superfluous. It seems to have as much to do with the scale and pace and narrative of *looking* (i.e. context within the overall volume of exhibits) as it does with the quality of any individual exhibit. I thought I knew what *display* was (it's my job) but this experience has turned that confidence upside-down.

The exhibition started out last autumn at Kettle's Yard in Cambridge, so densely displayed that it restored a sense of the village shop to their on-street premises. Then it was shaken up in the very difficult spaces of the Cornerhouse in Manchester in the New Year. Never hang a show after Christmas; the metabolism will never be right, goodwill will have been siphoned off in the previous weeks and the buccaneering gene which is essential to the mise en scène (including relatively static exhibition displays) will be only half awake. Even though it is now spring I am carrying the residues of those anxieties with me, amplified because I still have all sorts of ideas for things I want to add to this final showing. I'm not sure whether to keep this to myself, whether Roger and Jenni would prefer the illusion of minimum complications … As it is we are only just realising the implications of a late Easter for the hanging schedule. I decide to say nothing.

Camden Arts Centre is one of those places you cannot arrive at by accident, so any visit is strengthened by that sense of purpose, of getting there. It probably works so well as a gallery because, like everything in Britain, it is adapted from something else. It was a library until the mid-1960s and it still has an air of 1890s philanthropy about it. The three gallery spaces are exceptionally sympathetic. Jenni invented gallery education with Nick at the Whitechapel. She is a demon 'hanger', an artists' curator. She's also incredibly warm, which releases energies that frostier institutions have to go without. She's persuasive without being a flatterer. It was Jenni who persuaded me to do the *Making Do and Getting By* tape slide in 1985 when she was at the Whitechapel – probably the first time I showed something which celebrated the arbitrariness of narrative.

Checking over a space in anticipation of making an exhibition is always an odd transaction (but not nearly as odd as the studio visit). Today the galleries are still filled with Sophie Calle's exhibition, a cuckoo in the nest. Somehow I have to un-imagine her very showy show, but Camden hopes I will use some of the temporary 'walls' she is using. It's the kind of thing artists like to spot, the expedient element in exhibitions. I'm sure it'll be OK as long as it doesn't all feel like second-hand goods. The Sophie Calle show is nearly a book-on-the-wall exhibition – lots of reading, lots of tract-style display, lots of that French anthropological/forensic feeling, but with a whiff of the boudoir. It's claustrophobically sexy, it looks perfumed, but it isn't. I am impressed by the way her show occupies the space, but it's really formalistic – things in rows and at right angles to each other; just like page layouts, certainly nothing like the way I want 'Thinking Aloud' to behave. The most difficult gallery is the chapel-like space that overlooks Finchley Road's booming traffic. For some reason it always feels cold. Sophie Calle's formalism solves the problem perfectly by emphasising the long axis with two parallel lines of vitrines which look very French–medical. (This Joseph Cornell aesthetic will run and run. I call it Hermeticism.) Each vitrine is filled with a display of non sequitur things but arranged with the same particularity you see in shop windows in Atget's photographs. The vitrines stand like personages, and each vitrine is dated by year. The contents are her birthday presents. The encasing is a little like bottling wine but it's very 'Havisham-ish' and a hymn to the expression *d'un certain âge.* Wandering amongst her birthdays I decide it's too histrionic for me. Perhaps it's a gender thing – there are half a dozen British women artists whose work depends on a similar punctiliousness of presentation. Is this my critical beam shining, or is it just another matter of taste? Much as I like the way art induces this push and pull, it is a pervasive and fatiguing condition and I'm probably hardest of all on my own work …

I am sure I can mess this space up. 'Thinking Aloud' needs to look untidy but not in a studied way. It's essential that it defeats the worst clichés of the exhibition display, the

equally spaced row, the orthogonal template. If Sophie wants to leave one of her birthday/Egyptian afterlife displays behind I can easily sneak it into the show – near to something ostentatiously taxonomic, but perhaps within sight of Lutyens's preliminary drawings for the Cenotaph? 'Thinking Aloud' assumes, anyway, that spectators invent their own narratives, provided they are not forced down some programmatic route – and possibly even then too. 'Thinking Aloud' intends to be full of eventuality.

11.00 am

The meeting with Jenni and the Camden staff is a model of how these things can be – non-hierarchical but with a strong sense of engagement and support from everybody, no matter what their specific responsibility. Roger and Miranda from the Hayward, who have heaved this project, and me, up and over so many obstructions, look nervous about the mechanics of delivering all the exhibits and the amount of time I want to hang the show. I know I have to 'model' it by inhabiting the space, testing one thing against another. And I am resolute that we are not going to mimic various set pieces which we invented in the race against the clock in Manchester in January. There is some nervous teasing because they all suspect that I am still adding to the show. They're right! But they know better than to ask me. The truth is that *I* am nervous, although it's the same anxiety that generates the energy. Sharing my thoughts at this stage won't help, and I quietly admire their diplomacy. They know that I know that they know. Delivery day is set for 1 April – a collective giggle mops up some of the apprehension.

There is a monstrous rag-bag of things I still hope to get. One of those French folding ladders where the rungs fold into the stiles (only possible from a culture which included Marcel Duchamp and Jacques Tati). A transcript of Helen Sharman's deeply aesthetic account of looking back at Earth from her orbiting spacecraft, when she describes electric light leaking from the globe as one of our irresponsibilities (we have no idea what all this electro-magnetic energy does when it escapes). She *celebrates* it as a narrative component, how it visibly maps the world, making clear who has it and who hasn't, Europe glaring with light, Africa dark. I haven't even transcribed it yet but I like the idea of this piece of mute *text* on a sheet of A4 pinned to the gallery wall being so intensely visual. For those who can tolerate one book-on-the-wall exhibit there is a chance of merging the idea of the witness and that of the spectator. A nice man at the Knowledge (the examination that London taxi drivers undergo) has volunteered his huge map of London marked up with all the routes the cabbies have to learn. To me it's a piece of eloquent urbanism, marked with a 30-mile diameter limit – a sort of imaginary city wall: 'I only go this far, Guv.' The map looks like a huge cracked plate with all the finest fissures (the routes) concentrated in the oldest parts of the city. Its corners have those little tears that drawing pins make,

saving it from being mistaken for an artwork. As a Londoner I know most of the routes, but only as an animal, by experience. The thought of converting my knowledge (little k) to the language and mechanism of an examination is completely daunting. I have a tip that the University Museum at Oxford might lend me some William Smith drawings. He's known as the father of British geology. I like the way he followed his nose. He was a surveyor at the time mines were being sunk and cuttings and tunnels for canals were being made, and he was the first person to rehearse a geology based on collating information about levels at which fossil types were found. His drawings look superficially serviceable, but you can sense his pursuit of something as yet unknown and uncharted. Tom Sachs has promised to smuggle over one of his home-made guns – I hope he knows what he's doing. He works in New York and thrives on a sort of survivalist aesthetic. If you know how to make the guns work they are as dangerous, in an inaccurate way, as the real thing. Since they are made of ordinary bits and pieces of domestic hardware he assures me that nobody will know what they can add up to if his bag is searched. All our attempts to regulate violence are somehow embodied in his schoolboy exhibits …

My tourism of the various British centres of power and resources is fascinating – the government issues the same cheap furniture and the same bucket of paint to the Patents Office, the British Museum, the V&A, the Knowledge and the War Museum. On a bad day in an overheated basement corridor these institutions become indistinguishable. I think my job is to give back some of the vitality that the various loans possess, and generate some energy in the *terrain vague* which lies between them. Helen Sharman says that Australia is perfectly drawn by its illuminated coastal settlements with a vast black interior. Perhaps I am using exhibits to draw some large dark organic shape which we all inhabit but find so hard to name.

1.15 pm

Not a sign of Patricia – how late is fashionably late? I loiter impatiently with Roger and one of his roll-ups; Camden's noble entry steps are good for this new cultural phenomenon, Smoking-World of Exteriors. We chat about the drive to over-professionalise each specialism which has led to the new trade called *curating*. This is enjoyable because Roger is sufficiently confident, experienced and intelligent to call himself an exhibition organiser! He loves the subject, which is rarer than one might think. Monique Beudert at the Tate has been amazingly supportive, and interested in this project even though the promised loan of the Claes Oldenburg *Lipsticks in Piccadilly Circus, London* (his postcard collage in which he replaces Eros with oversize lipsticks) got fouled up in Tate bureaucracy. I'd imagined it not too far from Lutyens's Cenotaph sketch, similar graphic shorthand with calligraphic flourishes. I'll photocopy Oldenburg's 1966 proposed war memorial – a cube

to close off the intersection of Canal Street and Broadway – instead. A private acknow-ledgement of my favourite spot in New York, and the 'photocopy as stand-in' will double up as an irritant for spectators who think exhibitions must be framed. Monique is involved in the plans for the new Tate but won't give the game away. The rumour is that both the Tate and the Museum of Modern Art in New York have plans to stir up their col-lections … The pleasure of Roger's projects with artists is that they come with a 'voice' – it seems really unpromising to me to use the 'Thinking Aloud' model in a necessarily voiceless state institution, but better a risk taken than not, I suppose. Even though my show is so obviously opinionated and wilfully contradictory there are no texts to coax the spectator, only beautifully written telegrammatic labels for which I have to thank Roger.

2.00 pm

My impatience overtakes me so I leave a note for Patricia and decide to kill time at the Freud Museum where James Putnam (the only person at the British Museum who appears to like artists who are not dead) has organised a Sophie Calle 'interference' (how I hate the word 'intervention') back-to-back with the Camden show. The hill of Hampstead means that this morning's train ran in a tunnel immediately below Freud's house. The area looks exactly like a Berlin suburb; how do people find cultural duplicates so readily? I can just about remember the zigs and zags of the roads across the slope of the hill from my childhood, but it's a conundrum which I'm sure will confuse Patricia … Calle, not sur-prisingly, has tickled Freud's house with a variety of erotic tricks (the 'School of the Abandoned Shoe' sort of thing), enough to remind me of various childhood darknesses anyway. But it's essentially scenography. My parents, of course, never mentioned Freud even though we passed his house on the way to the swimming pool in Finchley Road. I'm beginning to panic about time. No Patricia. My children taught me to be better about time, so I recognise the character flaw. Why do we do it? It's ridiculous that I'm forced to hang round Freud's house and Calle's things thinking this stuff. Erika, the director, very kindly calls Camden and, yes, they think she left 40 minutes ago to meet up in Maresfield Gardens. It's a ten-minute walk! I lean against the suburban garden wall in the sunshine to escape the atmosphere and try to calm myself.

3.00 pm

Only 30 minutes till I'm meant to be at the Sir John Soane. Patricia has proposed quite an elaborate plan. She has an idea that my photographs and Gabriel Orozco's with Peter Fischli and David Weiss can make an argumentative show. She may be right, but I have to trust her to do it, and so do they. I don't think she recognises how secretive I am, how private I feel my photographs are, how I don't like looking at them, how I don't look at

them. They remind me of CV culture, forever making false narratives out of the past. For sure I'm not prepared to look through 20,000 images, I'd feel like a grave robber. I'm now sick with impatience but at least I've decided to let go; *she* can look through them, she can make a preliminary selection – and then we'll see. It'll be a first if we do it.

3.10 pm

Round the corner comes Patricia, unflushed and unworried, armed with her staggering beauty. Her style distracts me from her lateness. She registers my alarm but I can see that I'm going to be cast as the irascible, impatient father, just like mine. I try to cover my frustration … we can talk in the cab if we can get one.

3.20 pm

A cab on Fitzjohn's Avenue, with ten minutes to get to Lincoln's Inn … The downhill rush via Camden Town absorbs some of my anxiety, and Patricia's social ease and Latin enthusiasm for the project deals with the rest. Four Mexican museums are committed to the show, so, as often happens, it is a kind of *fait accompli*. Have any of the artists agreed, I wonder? The show will need an acute touch or it could be one of those apples-with-apples, pears-with-pears jobs. Whatever we have in common I don't see that a Mexican living in New York, two Swiss men who collaborate on all they do, and a Londoner, can have the same motives. I'm interested in motives, not motifs. Perhaps Patricia can rub the differences together, not the sameness.

3.40 pm

The traffic is completely stuck in Hampstead Road, and as I try to explain myself to Patricia I can hear how aggressive I'm becoming. I explain about the mountainous archive. Far from being put off, she seems delighted to undertake the task on her next visit. Decisions taken, bridges to cross. She will come to know *Making Do and Getting By* better than I do.

3.55 pm

Lincoln's Inn Fields. Patricia takes the cab on and I arrive, a sweaty and embarrassing 25 minutes late, at the Sir John Soane Museum. Hans-Ulrich Obvist is curating a Grand Interference in the Museum in November. I've known him for nearly ten years. He's a sort of whirling dervish of ideas and possibilities, running on a diet of mobile phone calls and espresso. He sends me things from Paris and the envelope is always stamped POINT D'IRONIE. I always misread it as PONT D'IRONIE but never remember to tell him my Ironbridge joke. I've worked with him on lots of things – shows, publications and endless

fantasies. He adores information and loves sharing it, which is not a description of a gossip; no sign of *Schadenfreude* in his Swiss-German, just boundless enthusiasm. The Sir John Soane Museum is one of London's most opinionated places – the 'voice' is clear and loud. Soane seems to sit in the hinge between modernity and the past, just before photography (what would he have done with it?) and the railway. The house retains a decorum I associate with my childhood, with rituals like signing the visitors' book. The Japanese love it. In a sense the house is full of violence, not really a collection but a lifetime's accumulation wedded to Soane's own architecture, an accumulation of salvaged antiquities all bearing signs of their wear, tear and refugee status. In the hall is a framed bullet hole in the plasterwork, a snapshot of an attempted armed robbery. If contemporary art tends to the theatrical, how will it measure up to something so fetishised, so real?

Typical of Hans-Ulrich to be so warm and unperturbed by my late arrival. He introduces me to Margaret Richardson, the Director of the Soane. These moments are so particular, when the diplomatic niceties cross the promise and practicalities of the project. Parties known and unknown. Margaret says how much she enjoyed 'Thinking Aloud' in Cambridge and how un-PC it was. I take this as a double-strength compliment. She says the Frank Gehry model, an exuberant Blue Peter-style three-dimensional collage in silver cardboard, gave her the idea to do a Gehry show at the Soane. Instant pleasure at the wondrous ways that information flows, some justification even. Explain to Whitehall.

4.15 pm

Margaret is very generous with her guided tour. Walking with her completely changes all sorts of habitual perceptions. In truth it's utterly humbling and notches up my anxiety and ambition as we dodge back and forth across Soane's displays. The overwhelming sense is of a shabby English calm, apparently disordered but everything in its place. Countless fragments, countless life stories. The word 'remains' dominates my impressions. Do I have anything to say? Don't accept invitations if you don't. We're nearly back to where we started and terror is overtaking anxiety.

5.15 pm

The walk home more or less follows the line of the now-buried River Fleet. It's also one of those 'London onion' walks, where the surges of development are legible, with the fuse of King's Cross and the railways setting off London's near-uncontrollable Victorian explosion of building. Fifty minutes takes in 50 years, 1790s to 1840s; enough for me to focus on Hans-Ulrich's project. There is a fragment of CCTV footage of a Japanese shopkeeper attempting to steady his swaying shelves and falling goods during the Kobe earthquake. Somehow it has the same *vanitas* quality as the Soane, the authenticity without an author

(like all surveillance material) but also a terrible souvenir. Salvage and loss. Loss and salvage. Lost and found. Most things in the Soane have fallen and been recovered. Pieces of news footage and still photographs in newspapers are perhaps the ready-mades of our time. I think of video, for the most part, as a chilly vulgarity, the tapestry of our day, representing enormous amounts of power but capable of displaying spectacle wherever it is projected. I expect other artists will use video at the Soane, so I will have to find my own route to signalling catastrophe, without being illustrative. I don't want to interfere with the calm at Soane, rather to make it tremble a little. At Ampton Street I stop and listen to the River Fleet racing below the manhole covers – the one place where you can hear the sounds of liquid waste converging from all the opinion-forming neighbourhoods of North London. The Fleet Sewer would delight Soane. What would Soane think of the Caledonian Road? What would he make of the rumble of the Piccadilly Line below? No signs of earthquakes here, of course, except the recurring social ones …

6.15 pm
Home.

Three messages introduced by BT's digital woman.

One from Nicholas at the Lisson Gallery. Can he come and see the new photographs? Could I do a show at the end of October? Exactly when Soane opens.

A passionate jet of enthusiasm from Patricia, already planning my visit to Mexico. Even when digitally chilled, her voice and delivery remind me that I'm an Anglo-Saxon. She wants to start on the archive *in the morning*. How will I possibly be ready? I'm going to have to let go.

A German voice, a Munich number. Haus der Kunst. Isn't that the gallery Hitler built? I'll find out tomorrow.

Postscript
The exhibition curated by Patricia Martin was a success and toured for eighteen months to considerable acclaim.

The exhibition at the Sir John Soane Museum was to be called 'Retrace Your Steps: Remember Tomorrow'. Wentworth's proposal to include the Kobe news footage in it initially created anxiety that a re-showing could be misunderstood as voyeuristic. 'Amusing', he reflects, 'that we prefer not to acknowledge that news is voyeuristic.' In any case, when the footage was traced it was so hedged about with copyright conditions that it was effectively unobtainable; the irony that authorless surveillance footage can be copyrighted was compounded by Wentworth's later discovery that it was being used by the Science Museum 'for entertainment purposes in their vaudeville earthquake exhibit'. This process took most of the summer of 1999.

Then Wentworth came up with a quieter, gentler, subtler solution. In the corridor, among the casts and masonry fragments, he placed an open copy of a broadsheet newspaper displaying fresh ruins and headlines of the day of the earthquake, with a Wedgwood cup with the coffee half drunk. 'It worked much harder for its place in the museum,' he says, describing it as 'a prop but not a scene'. Hans-Ulrich later rang him from Japan and read out the review in the Asian Times saying how moving it was.

photographer's notes

Before I started taking the pictures for this book, I tried to make some rules that would help me to connect them. One rule was: don't actively try to compose pictures. For example, when taking a portrait leave the subject in the middle of the frame, unless they are moving. My rules were full of get-out clauses.

My first subject was Shelagh Stephenson who insisted that most of her work was done lying on a sofa with her eyes closed. We agreed that the poodle parlour in Primrose Hill might prove more amusing for everyone, and it was close to the Hampstead Theatre where her new play was about to start rehearsals. The dog's haircut was a good way to start the day, it was a real situation and everything else we did was a kind of re-enactment, doing things that Shelagh had done or might do. We were cold and wet and looking for a cab, but Shelagh had to walk that part of the pavement by the railings four times before it felt right.

The photographs are notes, not complete sentences; the gaps should be visible.

I am not sure that Lawrence Norfolk knew what I was doing at his house on a Tuesday morning in October. We agreed to go down to the river. Lawrence moves very quickly, thinks and speaks very quickly too. I was always being left behind – through the reed beds, across the mud flats and in the conversations we had during those moments when I caught up with him or when he passed me on his way back. In his house Lawrence showed me his notebooks, which are like illuminated monastic texts. My notational photographs are closer to the smears of mud on my trousers or the fresh scar on my hand – evidence and residue. As I left Lawrence's house he spotted my damaged hand. 'Great scar,' he said.

Trust the camera to do the work. This is a snapshot rule. I have years of practice taking pictures while not looking through the viewfinder. It's not sneaky photography, it just means you can keep acting like a fairly normal human being while making images.

Jo Shapcott was on her way to Pittsburgh to see her brother and we agreed that an airport was a good place for me to take pictures as it was a normal location for Jo and fertile

territory for me: sad people, emotional people, bored people. After the check-in pictures and the glass lift pictures we stood by the departures gate and looked for other people's good-byes. A couple started an extended farewell of kisses and hugs. I asked Jo to stand next to them.

Collaborate. Work with the artists' ideas.

Locations and meeting places were not always easy to agree on. After shooting her rehearsal of *God's Penny* in St Giles Cripplegate, Errollyn Wallen wanted us to go to Cambridge for the rest of the pictures. I wanted to go to Deptford, near where she lives. I don't like Cambridge – too much history – and the thought of more church architecture filled me with dread, so we spent an afternoon walking through clanking industrial South London and around the markets in Deptford and Greenwich, listening to the noise of it all.

Don't think about any of the photographs you have done already. I was aware that in my desire for coherence I might start to repeat myself, technically and formally, but I felt that it was important not to suppress good ideas just because I had explored them already. I helped myself by not processing any film until I had finished taking all the pictures for the book.

I went to Brighton to see Joanna MacGregor, because she lives there, with her Caged piano and wild cats. The piano is 'Caged' with nuts and bolts and pieces of rubber. I couldn't believe that when Joanna played the re-tuned piano it sounded as if every note she hit was right, that any note she hit would be right. Joanna was anxious about something, but I can't remember what it was because I was too absorbed in my own thoughts concerning a current former lover whom I was meeting later. It all seems a bit foolish now I've listened to her wonderful Lou Harrison recording and read her diary.

Try and enjoy it. Of course I love what I do but sometimes it is difficult and frustrating. However, I didn't have enough time to be a moody bastard with these people and they all made this rule pretty easy to follow.

The venue for my meeting with Tim Supple was always going to be the RSC at the Barbican but the date was difficult to establish. Messages bounced between answer machines, appointments were cancelled and missed. When we eventually found ourselves in the same room in the same building at the same time we were accompanied by a young actor auditioning for a part in Tim's next production at the RSC. As Tim probed for

comprehension, the actor engaged with the text with a calm and courage that I found overwhelming; the fantasy actor in me was running for the door screaming every couple of minutes. I took some nice pictures of gesticulating and nail-biting. The casting was followed by half an hour's text bashing with the dramaturg. They sat opposite each other agreeing on massive cuts, like the Marx brothers going through their contract in *Night at the Opera*, only this time there really was no sanity clause. As they purged lines and scenes they mirrored each other's body language. I decided to continue the mirroring thing and we ended up doing a Robert De Niro/John Travolta/Tony Soprano – guy looking at himself in the mirror to check how he is positioned in the world – shot. It felt right to make Tim watch his own performance.

Avoid constructing narratives. This is as potentially destructive as overt composition. Take enough decent photos and the narratives will construct themselves.

I have known Shobana and Bobby for a long time and so this presented a whole new set of challenges. I wanted to do them justice but at the same time I didn't want it to seem that I was in any way 'in the know'. I thought the process should be no different from that for any of the other diaries. Bobby played and struggled to play in her studio and I joined in where I could. We walked up and down the garden path and got somewhere.

I must try and be there – this is not fly on the wall, not reportage.

Shobana was workshopping for a video project. She wasn't with her core company of dancers but the vocabulary remained the same and the work I did with her involved their bodies as much as her own. Shobana doesn't laugh a lot when there is a camera around but she has a great smile.

Shoot the crap ideas too – they often turn out to be good. And vice versa.

A walk through the King's Cross hinterland with Richard Wentworth should have produced more than enough material, were it not for his conspicuous puffa jacket. Many of the pictures I took when I was with him are his ideas rather than mine, although the '2WE cylinders', in which Richard and Michael Morris are reduced to cartoon dimensions by a chemical hazard sign, is mine. It is probably true to say that I would not have taken that picture with any of the other artists; it's an example of 'tuning in' – inspiration, if you like. Richard is very generous with his ideas and was constantly aware of situations which might work for me, happy to donate them to the project.

The pictures here are only a small part of all the material, fragments of fragments. There is a whole story about Joanna's cat on the table and an epic poem of pictures of Lawrence in the undergrowth. I hope the voices you hear in the diaries are somehow visible in the photographs.

Hugo Glendinning

Liverpool
Community
College